saints of the pueblos

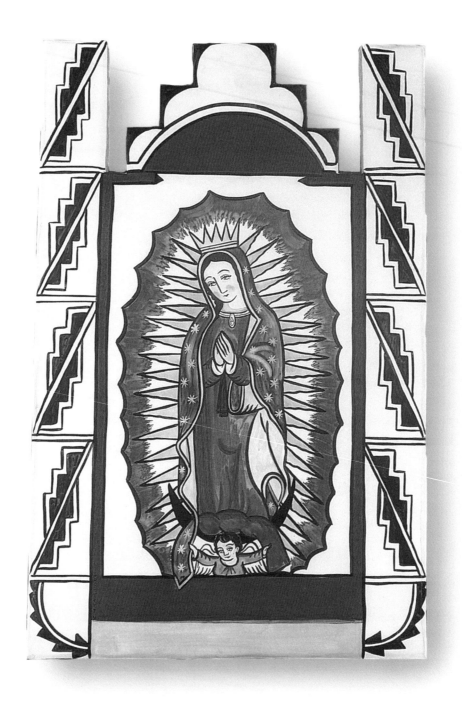

saints of the pueblos

charles m. carrillo

LPD Press. Albuquerque

For information: LPD Press
925 Salamanca NW, Los Ranchos, NM 87107-5647
Telephone: (505) 344-9382 www.nmsantos.com

Book and cover design by Paul Rhetts & Barbe Awalt
Photography by Paul Rhetts

ISBN 1-890689-30-0
ISBN 978-1-890689-30-8

Library of Congress Cataloging-in-Publication Data

Carrillo, Charles M.
Saints of the Pueblos / Charles M. Carrillo. -- 2nd ed.
p. cm.
Includes bibliographical references and index.
ISBN 978-1-890689-30-8 (pbk.)
1. Carrillo, Charles M. 2. Altarpieces--New Mexico. 3. Christian patron
saints in art. 4. Christian patron saints--New Mexico. 5. Pueblo Indians--
Missions. I. Title.
N6537.C3445A4 2008
704.9'482092--dc22
2008008731

contents

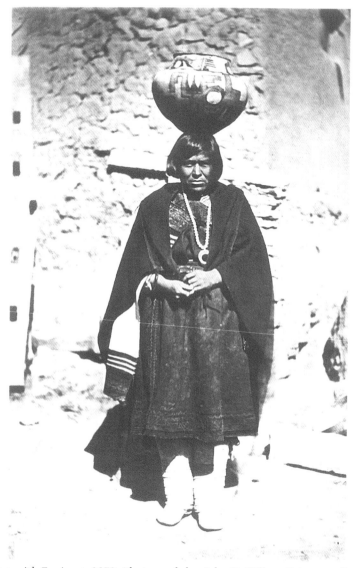

Woman with Zuni pot, 1879. Photograph by John K. Hillers. Private collection.

The Pueblo Indians and Hispanics of *Nueva España* are forever challenged by the Passion of Christ and his first followers to forgive one another and to love one another. I choose to forgive and to love, and to move our peoples into a new era of reconciliation.

In the early days of the twenty-first century our collective hearts were pierced once again by rogues of the world. Many of us were inconsolable in the pain and agony that we felt. Where did we turn as we sought to understand why? People of all faiths turned to their churches and places of worship for peace and understanding. Memories of my childhood experiences are the places I often return to in times of trouble. I am consoled by the memories of the people and love that surrounded me.

Some of my fondest childhood memories are of my service to the Church as an altar boy in my beloved Village of Encinal at the Pueblo of Laguna. I can still smell the incense and feel the hot candle wax dripping onto my hands as I assisted the *padre* with Stations of the Cross during the Lenten season. These were the times that I focused on the hand-carved retablos that hung on the walls of the sanctuary, as we moved reverently through the Passion of Christ. As a child I tolerated the hot wax as my way of empathizing with the Lord's suffering on my behalf. I was yet to learn about the atrocities that preceded me,

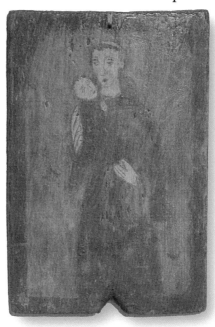

San Antonio de Padua retablo by Molleno, circa 1800. Collection of Paul Rhetts and Barbe Awalt.

as well as those that would follow. Very simply, I was being prepared to deal with both ends of the historical timeframe in which I am now living.

Like many people, physical depictions of saints and other spiritual beings have enabled me to focus on the Creator and his teachings. When I first saw Charlie Carrillo's work I felt an immediate warmth – a spiritual warmth. Perhaps it is the love that Charlie puts into his work, or perhaps it is the love of God expressed through him. Either way, I choose to accept Charlie as my brother, and to showcase his God-given artistic and intellectual gifts. It is our common desire that somehow our native and Hispanic peoples will recommit to the path of reconciliation and forgiveness that Our Savior and his early followers set-out on over two-thousand years ago.

On behalf of the nineteen Pueblo Indian tribes who own the Indian Pueblo Cultural Center, I would like to say that we consider ourselves blessed to serve as the host site for the Charlie Carrillo exhibit and book, which are both entitled — *Saints of the Pueblos*.

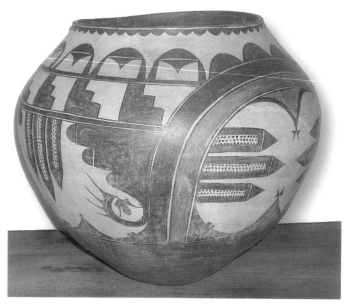

Zía Polychrome, ca. 1900, collection of Robert and Cynthia Gallegos.

It has been said that the Pueblo Indians often times keep the traditions of the Spanish settlers more faithfully than the descendants of the settlers. Certainly this is the case, it seems to me, in the devotion that the Pueblo Indians have for the patron saints of each pueblo. One of my great joys as Archbishop of Santa Fe is to visit with the different pueblos on their feast days. The day begins with a beautiful mass in the pueblo church followed by dancing and honor given to the saint. The image of the patron saint is carried in procession through the village to the place of honor in the main plaza.

Charlie Carrillo's efforts to feature the pueblo saints in this book are impressive. It is a unique opportunity for Hispanic and Indian traditions to come together in the common bond of the Catholic faith.

It is my hope that young Native Americans will treasure their traditional spiritual values and the richness of the Catholic faith brought by the missionaries 400 years ago. This book will help the reader see the cultural and religious treasures of the Pueblo Indians of New Mexico. Charlie Carrillo once again makes a great contribution through this book!

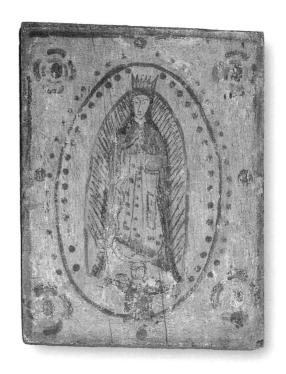

Nuestra Señora de Guadalupe retablo by José Benito Ortega, circa 1880. Collection of Paul Rhetts and Barbe Awalt.

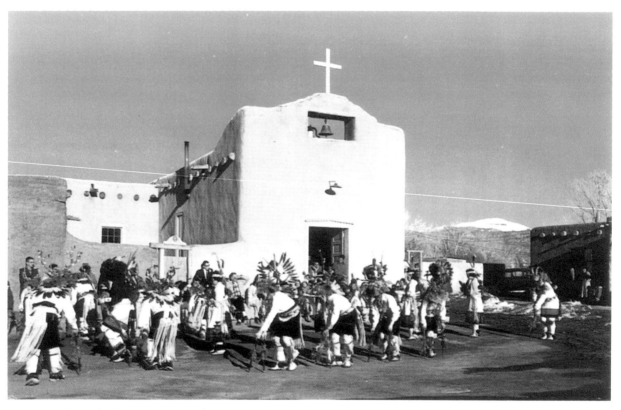

San Diego de Acalá de Tesuque Church, Tesuque Pueblo, H. Blumenschiem Collection, courtesy New Mexico State Records Center & Archives, #39747

the pueblos
by joe sando, pueblo historian

Good things happen to the good guys. In this case, the good guys are the Pueblo Indians of New Mexico. As history tells us, this is how the good fortune of the Pueblo Indians happened.

Following Coronado's expedition in 1540, forty-one years later, in 1581, a lay brother, Augustine Rodríguez, proposed a missionary expedition to the northern province. So he came accompanied by two other friars and nine soldiers led by Francisco Sánchez Chamuscado. Thus groundwork for Christianity was introduced. The soldiers returned to Mexico, but the friars remained, only to be killed by suspicious natives. Plans to organize a rescue party were soon made. Antonio de Espejo, a fugitive from the law, volunteered. Upon his return he made a favorable report of the area. So he petitioned the Viceroy to be allowed to return with a permanent settlement in the province. But before the authorities could act, Gaspar Castaño de Sosa decided to lead a colonizing expedition, without permission, in 1590. His group explored the Rio Grande pueblos and performed several special acts with might entitle the group to some sort of fame among present day Pueblo Indians. Members of the group erected a cross in the plaza of each pueblo they visited, al-

though no churches had yet been built. Only one replica of the original crosses remains to-

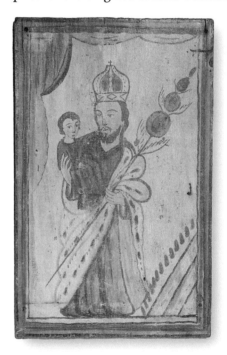

San José retablo by José Aragon, circa 1830. Collection of Paul Rhetts and Barbe Awalt.

day. It is at Zía Pueblo. Along with beginning the practice of giving each Pueblo a patron saint, de Sosa's group also appointed *alcaldes* and *alguacils* (sheriffs) at the Pueblos.

Today all nineteen pueblos of New Mexico, plus two or three Hopi villages, have a patron saint.

It is on the name day of each saint that the respective pueblos celebrate. Today, these feast days serve many purposes. Most tribal members return home to help in planning and participating in the activities such as dancing or singing or preparing food to serve to the many visitors. It brings the families together. Cooperation is the theme. The communities are cleaned. Houses used to be replastered with mud before the modern way of plastering. For many returnees, it is a time of renewal of their culture, language, and native religion. No wonder the 1980 U.S. Census first reported that the Pueblos Indians of New Mexico had retained the greatest amount of their native culture compared to any other American Indian tribes.

The publication of this book about the patron saints of the pueblos is timely and critical. The Pueblo Indian feast days are beneficial to New Mexico's economy as they attract scores of tourists.

santos de los pueblos
by charles m. carrillo

This is a celebration of the saints of the pueblos and the pueblo peoples whose goodness and devotion has kept the special feast days of the saints alive for the past four centuries. The acceptance of Christianity by the pueblo peoples is fraught with hardships and even controversy. The emergence and orchestration of a colloquial (informal) Catholicism at each pueblo by successive sacristans has resulted in a unique joining of heaven and earth. The sacristans are part of the elected "Spanish officials" also known as *fiscales*. These pueblo men deal with the "outside" world composed of both civil and Roman Catholic entities.

Saints of the Pueblos is about the devotions of the pueblo peoples of New Mexico. The Franciscan fathers who missionized New Mexico in the late 16th and early 17th centuries named each pueblo for a different Catholic saint. Since that time, the devout pueblo peoples have given honor to their saints and have faithfully celebrated their feast days with reverence and ceremonial dances.

The historical context in which the saints were chosen for missions has been lost. It is believed that each of the patron saints was likely chosen for any of several reasons, including proximity to a specific date, the patron or devotion of the founder of a mission or the Franciscan friar, or the usurpation of a pueblo ceremony. A saint was chosen for each pueblo and, in some cases, that choice has changed. Unfortunately, the reason for the change is now also lost in the historical

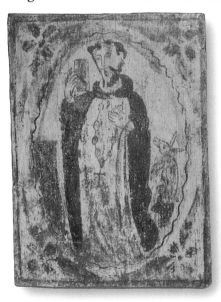

Santo Domingo retablo by Molleno, circa 1800. Collection of Paul Rhetts and Barbe Awalt.

9

record. The patron saints represented in this collection are the saints that are now celebrated in each of the surviving pueblos.

The patron saint of each pueblo is embodied in the tangible wooden or plaster *santo* that is honored during the great feast days with a Catholic mass and essential dances. In short, the "holy" is available to the villagers, friends, and even outsiders in a manner in which it is not accessible to anyone situated elsewhere in the "outside" world. The "holy" is present at the Catholic mass or in the native dances. As it is among traditional Hispano peoples of New Mexico, a limited but real share of the actual saint in heaven is believed to be present in the *santo* at each pueblo. Because of this, the saints are said to live at the pueblos.

I work as a *santero* or saint-maker and have dedicated the past twenty-three years to understanding 18th century New Mexican iconography and the saint-makers who created these historic *santos*. Each of the retablos, or panels, depicted here has been prepared with homemade natural pigments, a hand-adzed pine panel and piñon sap varnish. The iconography of each *santo* is based upon traditional prototypes.

My doctoral research in archaeology concentrated on historic pottery. Therefore, I have a keen interest in the historic ceramic traditions of the pueblos. Each retablo is painted with historic pottery designs and elements associated with that pueblo. The elements I have incorporated in the retablos are influenced by actual pieces of pueblo pottery dating from 1600 to 1900.

The pottery pictured is an example of the historic wares made at each pueblo and is not necessarily the pot used for the retablo designs. In many cases, the designs used on the retablos are not associated with any one pot, but rather a collection of many sources. The meaning of most design elements was known when they were made. However, the meanings of these designs is lost today, except to Pueblo people's themselves.

Each retablo shape was chosen conditioned by the design elements from each pueblo. Each retablo shape is different. The designs from each pueblo helped determine the shapes used in these retablos.

It is my hope that this presentation of the pueblo saints will bridge the artistic traditions of the saint-makers and the pueblo potters of New Mexico.

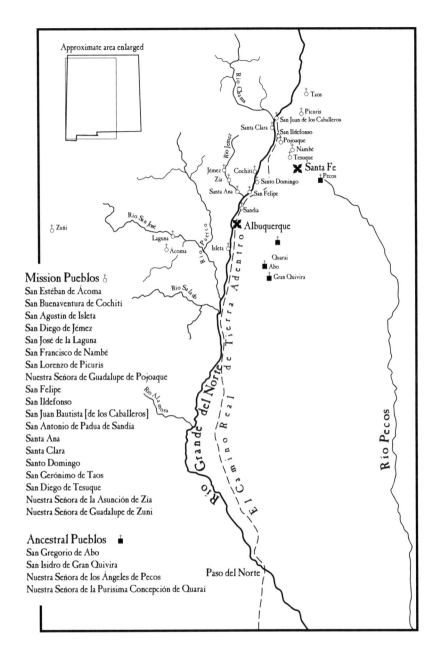

Approximate area enlarged

† Taos

† Picuris
San Juan de los Caballeros
Santa Clara ○ ⌀ San Ildefonso
○ Pojoaque
Ȯ Nambé
Ȯ Tesuque

✖ Santa Fe
† Pecos

Jémez ⌀ † Cochití
Zía ⌀ ⌀ Santo Domingo
Santa Ana ⌀ San Felipe
Sandia

Río Chama
Río Jémez
Río San José
Río Puerco
Río Salado
Río Alamosa
Río Grande del Norte
El Camino Real de Tierra Adentro
Río Pecos

○ Zuñi

Laguna
○ Ácoma
○ Isleta

✖ Albuquerque

■
Quarai
■ Abo
■ Gran Quivira

Mission Pueblos ○

San Estéban de Ácoma
San Buenaventura de Cochití
San Agustín de Isleta
San Diego de Jémez
San José de la Laguna
San Francisco de Nambé
San Lorenzo de Picurís
Nuestra Señora de Guadalupe de Pojoaque
San Felipe
San Ildefonso
San Juan Bautista [de los Caballeros]
San Antonio de Padua de Sandía
Santa Ana
Santa Clara
Santo Domingo
San Gerónimo de Taos
San Diego de Tesuque
Nuestra Señora de la Asunción de Zía
Nuestra Señora de Guadalupe de Zuñi

Ancestral Pueblos ■

San Gregorio de Abo
San Isidro de Gran Quivira
Nuestra Señora de los Ángeles de Pecos
Nuestra Señora de la Purísima Concepción de Quaraí

Paso del Norte

The Pueblos of New Mexico, 1598-1800

acknowledgements

In the late autumn of 2002, Pat Reck of the Indian Pueblo Cultural Center in Albuquerque asked me to consider a show of my santos. The show would feature the saints of the pueblos. With a simple handshake I agreed to paint a retablo of each of the patron saints of the nineteen pueblos of New Mexico. Only months before the show was slated to open Pat passed away and we all lost a dear friend.

The professional staff at the Indian Pueblo Cultural Center filled in, especially the newly appointed curator, Elizabeth Akiya Chestnut. The show opened on schedule on August 28, 2003. Ron Solimon, Director of the Indian Pueblo Cultural Center, opened the show with energetic words that encouraged a commitment to "bridge the gaps" between Hispanics and the pueblo peoples of New Mexico. The show was a great success. Encouraged by the public response, I was asked to do a repeat performance.

Many people at the show commented that this would make a great book. My friends Paul Rhetts and Barbe Awalt suggested publishing this book featuring the original retablos that I painted. I am indebted to all these individuals, most especially Pat Reck, who encouraged the idea of the first show. I am grateful to my wife Debbie and my chil-dren, Estrellita and Roán, for their continued encouragement of my many "projects."

A special thanks go to Archbishop Shee-han, Joe Sando, Robert and Cynthia Gallegos, Bill and Barbara Douglas, and Glenn Fulfer, Leslie Newkirk, and Albert Lovato of Salinas Pueblo Missions National Monument, who also helped make this project happen. I also want to thank the many private collectors who own the retablos pictured in this book.

My greatest appreciation goes to the *santeros* of the seventeenth, eighteenth, and nineteenth centuries who made *santos* for the pueblos, and for the great pueblo potters of the past four centuries. Their crafts are the silent contributions to a rich multi-cultural history of New Mexico. I am grateful to play a role in bringing the two traditions together in the *Saints of the Pueblos*.

Charles M. Carrillo

saints of the pueblos

ácoma pueblo
san estéban de ácoma

The Pueblo of Ácoma, a Western-Keresan-speaking pueblo, is the longest occupied pueblo in New Mexico. Archaeological evidence suggests that the pueblo has been occupied for at least 1000 years (Ruppé 1953). The first European accounts of Acoma date to 1539 when Fray Marcos de Niza wrote about Ácoma in his account to the Viceroy of New Spain. His reports were based upon accounts of the black servant Estéban, who is likely the first non-Indian to enter or see the Pueblo.

By 1540, Francisco Vásquez de Coronado dispatched Capitán Hernando de Alvarado to Ácoma. Fray Agustín Rodríguez and Francisco Sánchez Chamuscado visited Ácoma in 1581. Diego de Vargas visited Ácoma on November 4, 1692, and planted a cross at the Pueblo. It is recorded that many pueblo people accepted Christianity at this time (Bancroft 1889:200-201). A mission was established at Ácoma in 1699 by Pedro Rodríguez Cubero. As a Spanish mission, Ácoma was called San Estéban de Ácoma.

The feast day for San Estéban, or Saint Stephen, is December 26; however, confusion with St. Stephen, King of Hungary, changed the feast day to September 2nd (Domínguez 1956:188-191). San Estéban (Acts 7:60), known as the first martyr, was stoned to death. In Colonial art, he is shown dressed in the robes of a deacon, holding a palm branch, a symbol of his martyrdom, and carrying stones in his hands.

Ácoma pottery is characterized by its thin, hard-fired walls and its light weight. Ácoma

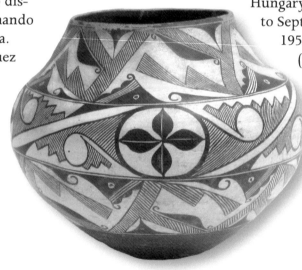

Ácoma Polychrome, circa 1910, collection of Bill and Barbara Douglas.

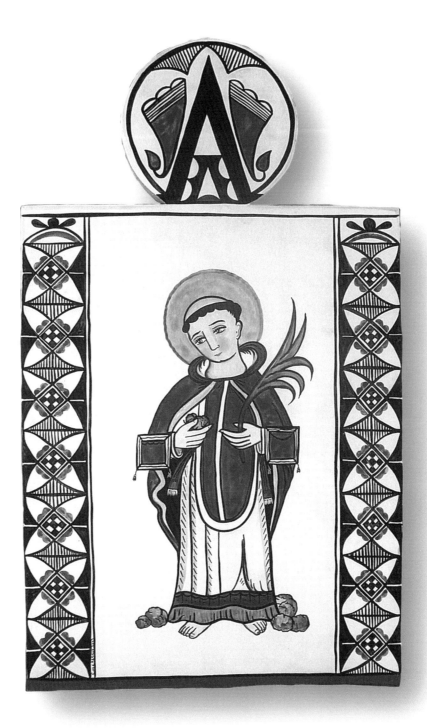

15

clay is frequently mixed with a temper of crushed potsherds.

The border and lunette motifs on this retablo are derived from Ácoma Polychrome pottery, which is known for its cream to white slip and matte black and red mineral paints. The repeating geometrical decorations are derived from a bowl from the School of American Research in Santa Fe, dating to 1880-1900.

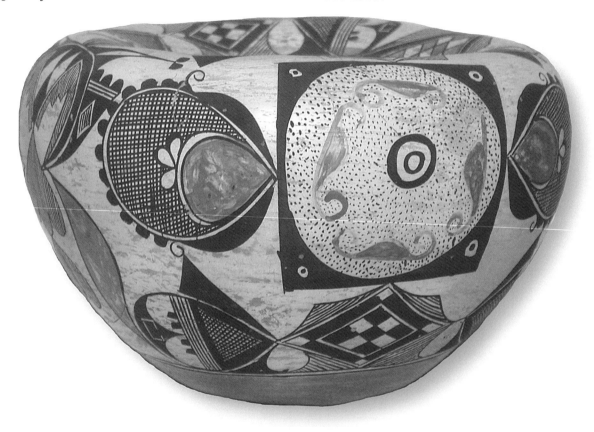

Ácoma Polychrome, ca. 1890, collection of Paul Rhetts and Barbe Awalt.

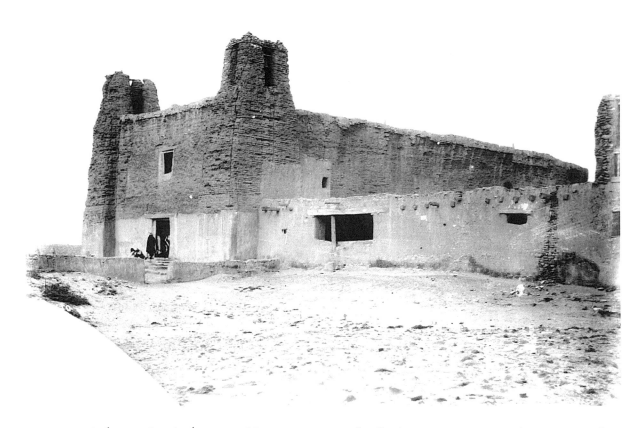

San Estéban de Ácoma Church, Ácoma Pueblo, ca. 1899, E. Boyd Collection, courtesy New Mexico State Records Center & Archives, #35761.

cochití pueblo
san buenaventura de cochití

Cochití is an Eastern-Keresan-speaking pueblo located on the west bank of the Rio Grande below La Bajada Hill between Albuquerque and Santa Fe. The pueblo has been occupied for over 400 years. Several pueblo groups including representatives from the Pueblo of Cochití met with Juan de Oñate in July 1598, when rods or canes of office were distributed (Bolton 1916:202-203). A resident friar was assigned to Cochití in 1637 (Scholes and Bloom 1945:66). Scholes indicates that it was not until 1667 that the mission at Cochití was first named for San Buenaventura (Scholes 1929).

The first post-Revolt mention of Cochití was made by Governor Francisco Cuerbo y Valdés in 1705 (Bancroft 1889:228). In 1706, Fray Juan Olvarez made the comment that a church at Cochití was being built under the charge of Fray Miguel Muñiz (Hacket 1937:375). The history of the mission at Cochití is lacking; however, a large church was noted by Domínguez in 1776 and named for San Buenaventura (Domínguez 1956:155-159). By 1818, Cochití was a mission of Santo Domingo, under the charge of Fray Juan Caballero Foril (Biblioteca Naciónal, *Legajo X:* Doc. 79-80).

San Buenaventura, or Saint Bonaventure, lived from 1221-1274 and is known as a theologian and doctor of the Catholic Church. He joined the Franciscans in 1238 and wrote the official biography of St. Francis of Assisi. He was canonized in 1482 and was declared a doctor of the Church in 1588. His feast day is July 14. He is shown wearing the indigo blue robes of the Conceptionist

Cochití Polychrome, ca. 1920, collection of Indian Pueblo Cultural Center, D81.15.7.

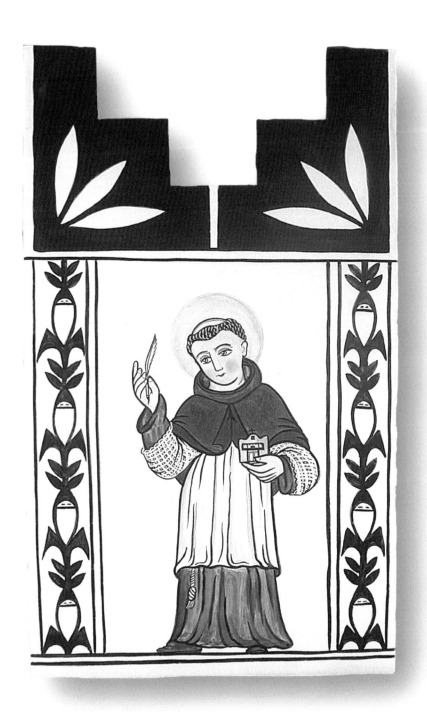

Franciscans and a red cardinal's cape. Since the fourteenth century, he has been depicted holding a small model of a church, a symbol of his devotion to the church. In this image, he holds a model of the church at Cochití.

The retablo border motif is based upon a Kiua Polychrome design from Cochití dating from 1870-1910. The stylized plant motif on the sides of this retablo is interpreted as a corn stalk symbol, which may refer to fertility. The upper portion of the retablo is also based on a step-design of a Cochití Kiua Polychrome pot.

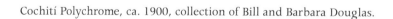

Cochití Polychrome, ca. 1900, collection of Bill and Barbara Douglas.

20

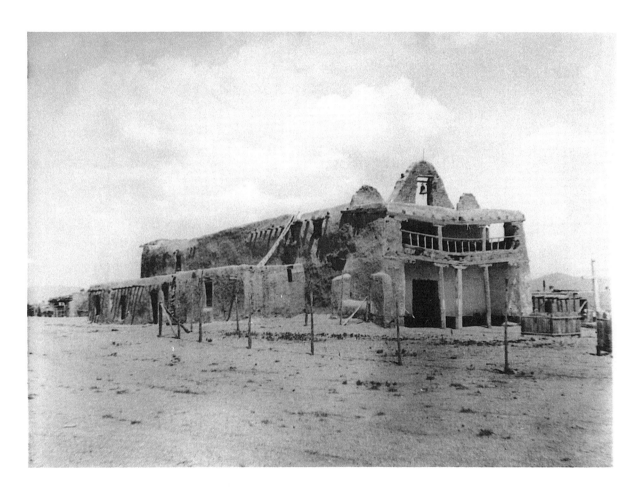

San Buenaventura de Cochití Church, Cochití Pueblo. Courtesy Museum of New Mexico, neg. no. 2298.

isleta pueblo
san agustín de isleta

The Pueblo of Isleta is a Southern-Tiwa-speaking pueblo located south of Albuquerque on the west bank of the Rio Grande. The occupation of this pueblo predates Spanish contact. The original mission of the pre-Revolt era was named San Antonio de la Isleta and renamed San Agustín de la Isleta after 1710 (Ellis 1979:364). In 1742, eighty families returned from the Hopi area to the present pueblo, and this event may be the stimulus for the building one of the largest of the present-day pueblos (Thomas 1935:102).

In 1881, a contingent of Laguna peoples moved their ritual paraphernalia to Isleta and settled there. These immigrants introduced polychrome pottery to Isleta. Before that date most of the Isleta pottery was of a utilitarian type.

San Agustín, or Saint Augustine of Hippo, lived from 354 to 430 AD. His feast day is August 28. This doctor of the Latin Church was a convert to Christianity. His mother was Saint Monica. He is shown with a flaming heart, an allusion to the mystical union of Christ and Augustine as well as his devotion to God.

Traditional Isleta pottery was red-on-tan made with a tan clay, sand temper, and red slip.

The pottery motif on this panel is derived from the small Isleta Polychrome bowl pictured below, which dates from the late 1890s to the mid-1920s. The design element is believed to be a geometric checkerboard design. This bowl clearly shows the Laguna influence of the pottery in its use of complex designs and color.

Isleta Polychrome, ca. 1920, collection of Charlie and Debbie Carrillo.

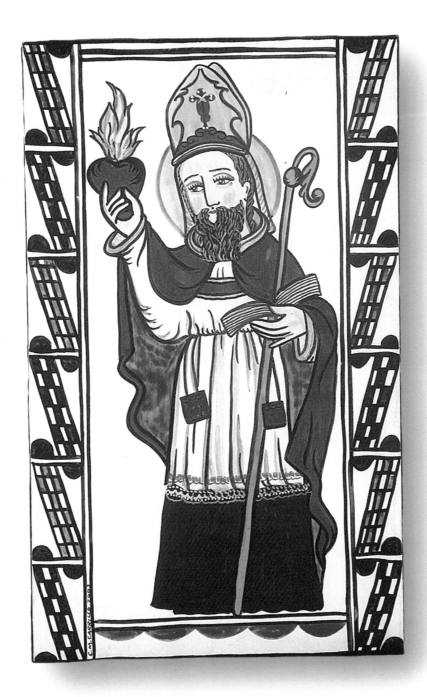

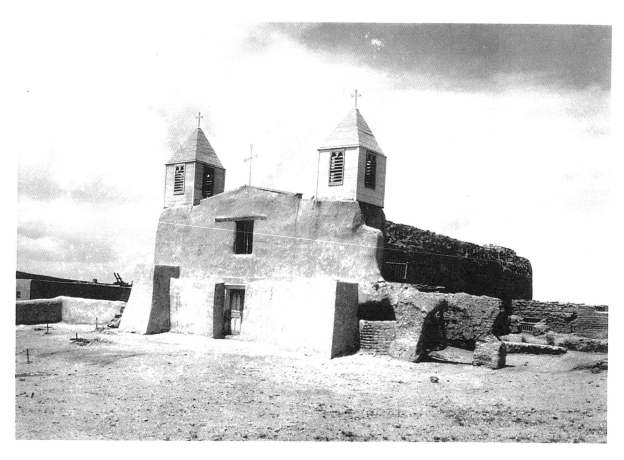

San Agustín de Isleta Church, Isleta Pueblo, DOD Collection, courtesy New Mexico State Records Center & Archives, #2805.

jémez pueblo
san diego de la congregación de jémez

J émez (sometimes called *Walatowa*) is a Towa-speaking pueblo and is located on the east bank of the Jémez River, northwest of the Pueblo of Zía. Early Spanish chroniclers noted several Jémez villages in the Jémez district. By 1600, Fray Alonso de Lugo had established the first mission known as San José at the Pueblo of Giusewa. Fray Gerónimo de Zarate Salmerón established a mission at the present site of Jémez in 1621-22 (Bloom 1946). It was known as San Diego de la Congregación (Domínguez 1956:176-182; Scholes 1938:64). After the Pueblo Revolt, the people built a new church immediately east of the first church. They built this church sometime after 1703 and named it San Diego de los Jémez. It stood until 1887-88 when a third church was built (Sando 1979:418-429).

San Diego de Alcalá is known in Latin as Saint Didacus. He lived from 1400 until 1453. His feast day is November 12. This Franciscan lay brother was invoked for the cure of Don Carlos, son of King Philip of Spain. The king credited Diego with his son's recovery and raised Diego from obscurity to canonization in 1588. San Diego is shown in this rendition embracing a flower-covered cross.

The pottery chosen for this retablo is Jémez Black on White, a pottery type known in the Jémez district from 1500 to the time of Spanish contact in 1598. It is interesting to note that this design was in use at the time of the canonization of Diego. Archaeologists refer to the designs on the retablo as "sacred mountain" motifs.

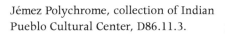

Jémez Polychrome, collection of Indian Pueblo Cultural Center, D86.11.3.

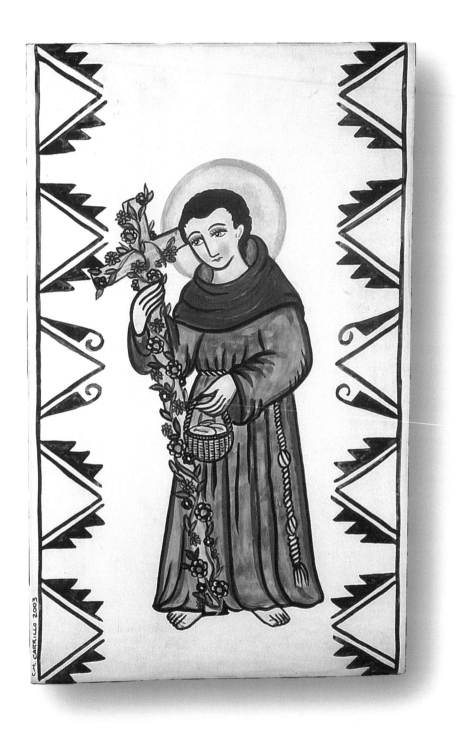

San Diego de la Congregación de Jémez Church, Jémez Pueblo, F. Marple Collection, courtesy New Mexico State Records Center & Archives, #21145.

laguna pueblo
san josé de la laguna

The Western-Keresan-speaking Pueblo of Laguna was established on the Río de San José sometime after the recolonization of New Mexico, about 1697. The pueblo was named for San José de la Laguna, or Saint Joseph of the Lake, for it came to be built on a small lake formed by beaver dams. The dam was eventually washed out in a flood in 1855 (Harrington 1916:541). On July 4, 1699, Spanish Governor Pedro Rodríguez Cubero along with the Franciscan Vice Custos (provincial leader) confirmed San José as the patron saint of Laguna (Domínguez 1956:183). Historians believe that the church was built as early as 1700. The great altar, painted by an Hispanic *santero* known only as the Laguna Santero, was fabricated and painted sometime between 1800 and 1808 *(Boyd 1974:155-169)*.

Saint Joseph is the foster father of the Christ Child. His feast day is March 19. This rendition of Joseph is derived

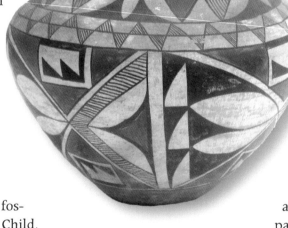

Laguna Polychrome, ca. 1900, collection of Bill and Barbara Douglas.

directly from the great altar screen at Laguna. Joseph wears the colors yellow, a symbol of marriage, and green, a symbol of new life. The Christ Child wears the color red, which is the color that symbolizes sacrifice. Joseph is often depicted in a red robe. Joseph holds a staff with a flowering hollyhock. This flower is known in local Spanish as *"varas de San José"* or 'Staff of Saint Joseph.' Joseph is the most frequent male saint in New Mexico (Awalt and Rhetts 1998:173).

The pottery traditions at Laguna Pueblo closely parallel those of Ácoma; techniques, materials, and designs are nearly identical. While

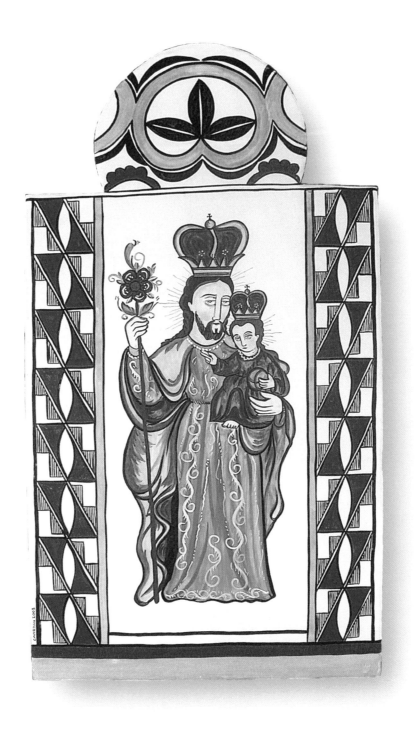

black crushed rock is sometimes used to temper the local clay, crushed potsherds are also used, making the paste virtually identical to that at Ácoma.

The design used as a border motif is derived from a type of pottery known as Laguna Polychrome, a style that dates from about 1900-1920. The semi-circular top portion of this retablo, known as a lunette, contains a Laguna Polychrome design that dates from 1880-1900. Framing lines painted horizontally on this type of pottery define the area that contains the saint. This retablo has two parallel framing lines at the top and one at the bottom where a red slip would typically define the base.

Laguna Polychrome dates from 1830 to about 1940. It is characterized by a tan to creamy stone polished slip, and mineral black and red matte paints. Vessel interiors are usually slipped red.

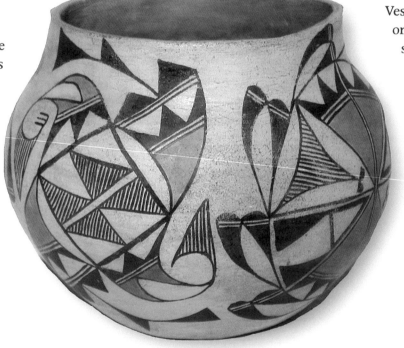

Laguna Polychrome, ca. 1900, collection of Barbe Awalt and Paul Rhetts.

30

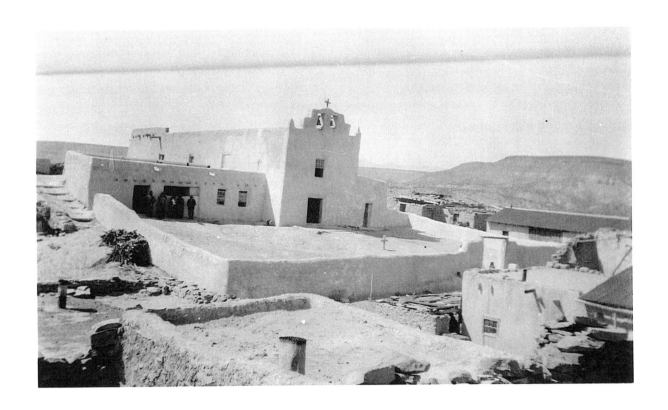

San José de Laguna Church, Laguna Pueblo, Bergere Family Collection, courtesy New Mexico State Records Center & Archives, #21556.

Nambé, a Tewa-speaking pueblo, located 15 miles north of Santa Fe, is one of the smallest pueblos. Fray Atanasio Domínguez (Domínguez 1956:52) provides one of the most extensive accounts of this pueblo, writing that it was missionized in early 1600s. The first church was destroyed in the Pueblo Revolt and was rebuilt in 1729 under the patronage of San Francisco de Asís. That structure remained until 1909. The replacement church stood until 1960. The present church was dedicated in 1975 (Spiers 1979:318).

San Francisco de Asís, or Saint Francis of Assisi, is shown in the indigo blue habit of the Conceptionist Franciscans who missionized New Mexico, a reference to the doctrine of the Immaculate Conception and the color blue as an attribute of the Virgin Mary. His feast day is October 4. With few exceptions, the New Mexican *santeros* always depicted the Francisan saints in the indigo blue robes. In this retablo, Francis holds a skull and a crucifix, along with the marks of the stigmata, his typical attributes in colonial New Mexico. St. Francis is the sixth most frequent saint in New Mexico and the third most important male saint (Awalt and Rhetts 1998:173).

Nambé potters share the Tewa potting traditions. They used the same clays tempered with local vitric tuff (volcanic rock containing glass). Nambé's clay also includes mica. There is no evidence of polychrome pottery at Nambé Pueblo. Very little historic pottery remains and none were available for illustration purposes.

The geometric pottery design used as a border motif resembles the Kiua pottery of Santo Domingo; however, Nambé potters likely adapted the highly prized Kiua-wares and used these designs for their own pottery. It is possible that Nambé potters, working in colonial Santa Fe, copied the Keresan Kiua wares for the Santa Fe market. The addition of dots and other decorations is a feature that distinguishes this pottery style from wares made at other Pueblos. Potters at Nambé made this type of pottery between 1760 and 1825.

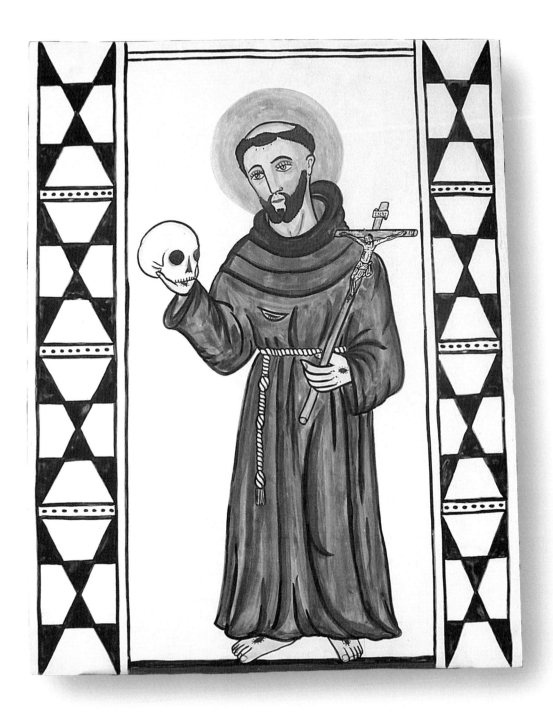

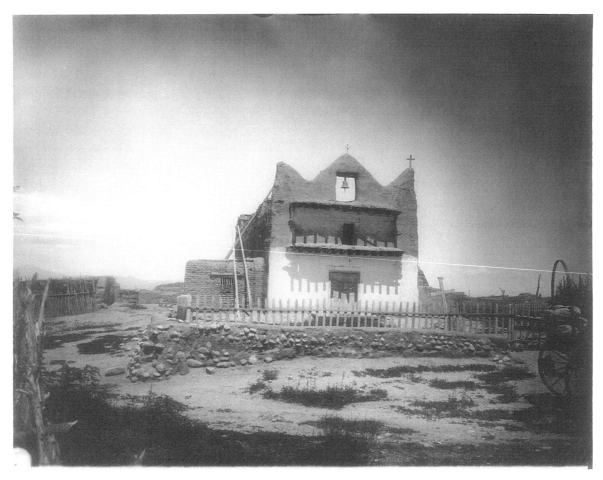

San Francisco de Nambé Church, Nambé Pueblo, 1899. Photo by Adam C. Vroman, Courtesy Museum of New Mexico, neg. no. 14298.

ohkay owingeh pueblo
san juan bautista

Ohkay Owingeh, formerly known as San Juan Pueblo, is a Tewa-speaking pueblo located on the east bank of the Rio Grande, just north of its junction with the Río Chama. The Pueblo officially changed its name to Ohkay Owingeh in 2005. The Coronado expedition of 1540-41 was probably the first European group to enter this pueblo (Hammond and Rey 1940:244:259). Gaspar Castaño de Sosa visited San Juan again in 1591. In 1598, Juan de Oñate settled his expedition across the river from San Juan at the Pueblo de Yunge, where villagers gave up their homes and moved across the river to the present site of San Juan. For their kindness and their hospitality, the Spanish settlers bestowed on them the name San Juan de los Caballeros, or Saint John of the Gentlemen (Harrington 1916:213). The mission church at San Juan was built as early as the 17th century, however it was destroyed by 1900. A new mission replaced the old one in 1913.

San Juan Bautista, or Saint John the Baptist, is known from Biblical accounts as the forerunner of Christ. He baptized Christ and referred to him as the "Messiah." According to Luke, he was a cousin of Jesus and the Lamb of God. His feast day is June 24. He is shown in colonial art as a desert hermit.

San Juan Pueblo is not known for a painted potttery style; however, it has been well known throughout the past two centuries for its production of highly prized polished red-on-tan wares. More recently it has come to be associated with a prehistoric Tewa ware known as Potsuwi'i Incised. This retablo is painted with the polished red ware frame. The secondary border, a crosshatch pattern, is a design from the Potsuwi'i Incised wares.

San Juan Red on Tan, ca. 1900, collection of Bill and Barbara Douglas.

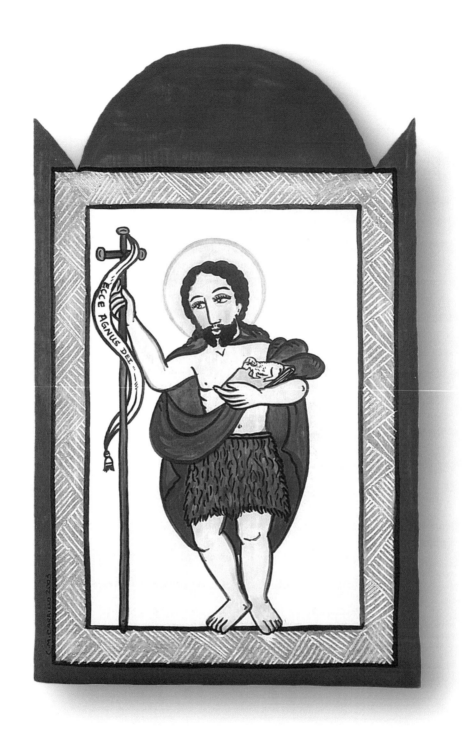

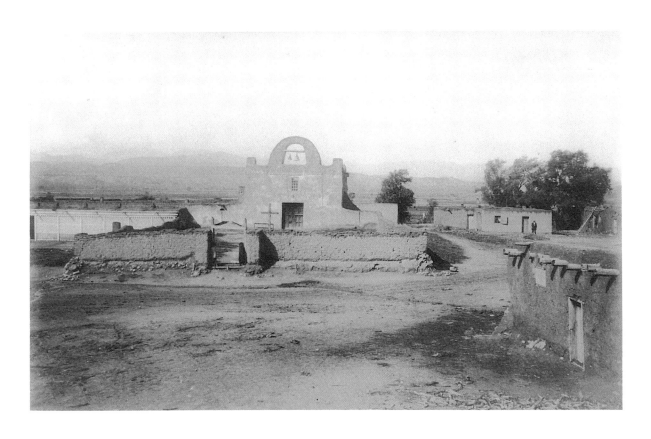

San Juan Bautista Church, Ohkay Owingeh Pueblo. Photo by William H. Rau, Courtesy Museum of New Mexico, neg. no. 100000.

picurís pueblo
san lorenzo de picurís

Picurís is a Northern-Tiwa-speaking pueblo located on the western slope of the Sangre de Cristo mountains in the Río Pueblo valley. Picurís was first visited in 1591 by Gaspar Castaño de Sosa (Jenkins 1966; Castaño de Sosa 1965:124). Juan de Oñate named the pueblo for San Buenaventura in 1598, and Franciscans likely established a mission church before 1680. The pueblo was abandoned for almost a decade during the Pueblo Revolt; the Picurís people returned to the pueblo in 1706 (Thomas 1935:76).

It was during this time period that San Lorenzo, or Saint Lawrence, was made the patron saint of the Pueblo of Picurís. Fray Atanasio Domínguez provided a very good description of Picurís in 1776 (Domínguez 1956:92-101). The old mission remained in place until 1980 when pueblo leaders determined that the mission had to be rebuilt, tore down the old church, and constructed a new mission in its place.

San Lorenzo's feast day is celebrated on August 10. Arch-

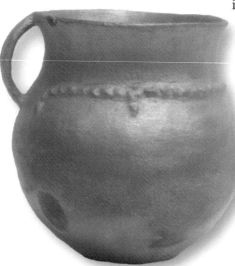

Picurís Micaceous, Rosita Martínez, ca. 1957, collection of Bill and Barbara Douglas.

deacon of Rome, he was a Spaniard by birth and was martyred in 258 AD. He is shown with a gridiron, a symbol of his martyrdom.

Picurís Pueblo is known for its micaceous utilitarian ware, a type of pottery that is closely associated with the micaceous wares made by Apache peoples in the late 1600s and early 1700s. The clay needs no temper. The pueblo is not known for a painted pottery tradition. Picurís pottery is often made with bosses (small bumbs or knobs) on the shoulders and or scalloped rope fillets (narrow bands) that encircle the upper body. The border of this retablo utilizes both boss and rope fillet design elements.

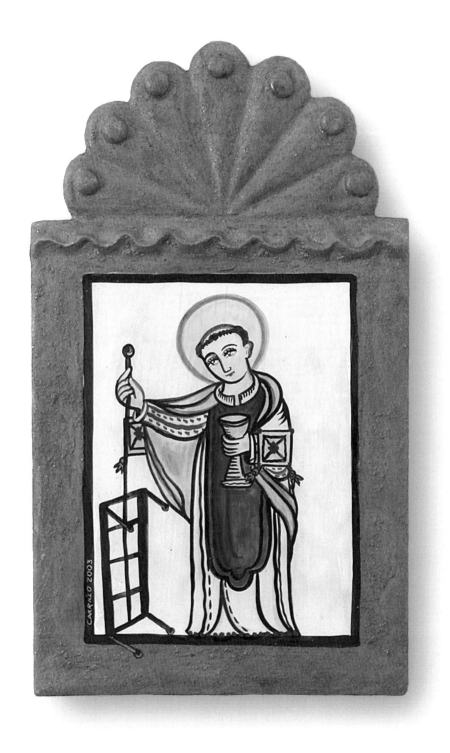

39

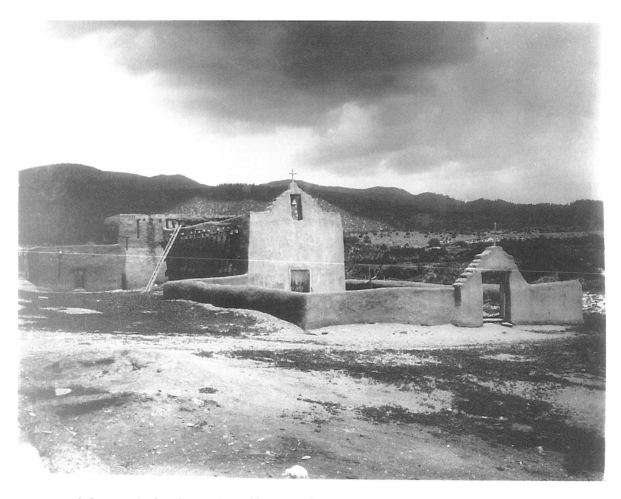

San Lorenzo de los Picurís Church, Picurís Pueblo, 1899. Photo by Adam C. Vroman, Courtesy Museum of New Mexico, neg. no. 12359.

pojoaque pueblo
nuestra señora de guadalupe de pojoaque

Pojoaque is a Tewa-speaking pueblo located north of Santa Fe at the junction of U.S. 285 and U.S. 4. This pueblo, once considered to be almost abandoned, has been the fastest growing pueblo for the past forty years. The location of the pueblo is identical to that recorded in 1598 (Hammond and Rey 1953, 1:opp.p. 584). Following the Pueblo Revolt, Governor Francisco Cubero y Valdés re-established Pojoaque in 1706 (Lambert 1979:325). Sometime later, a church was built. Fray Domínguez referred to the pueblo as Nuestra Señora de Guadalupe in 1776 (Domínguez 1956:60). and a priest resided there in 1782 (Benavides 1945:236).

The Colonial church was torn down after 1916 and a new church was built in the 1920s. This church was replaced by still another structure in 1965. The new structure is not located in the plaza of the pueblo, but rather in a more centrally accessible location.

Nuestra Señora de Guadalupe, or Our Lady of Guadalupe, is a title of the Virgin Mary derived from the miracle story of San Juan Diego at Tepeyac near Mexico City. In this image, the Virgin of Guadalupe is depicted as she appears in many colonial retablos from New Mexico. Her feast day is December 12. This image is derived from the miraculous image that appeared on the *tilma* (cape) of the Mexican Indian Juan Diego. Diego was instructed by the Virgin to take roses that were collected on the cold winter day of December to Bishop Zumárraga as a sign of her presence. The story is told that when Juan Diego opened his *tilma* carrying the roses, her image sudenly appeared on the cloth. Juan Diego was finally canonized in the summer of 2002. The Virgin of Guadalupe is the second most frequent image of the Virgin (Awalt and Rhetts 1998:173).

No historic pottery was available for illustration purposes.

The pottery design used on this retablo derives from a pottery type known as Pojoaque Polychrome. This pottery intergrated aspects of Tewa Polychrome from the early 1700s and Powhoge Polychrome from the mid-1700s (Harlow 1973:31). Pojoaque Polychrome vessels are predominately polished red wares with a small band of designs in black and white. This pottery dates from 1720-1760.

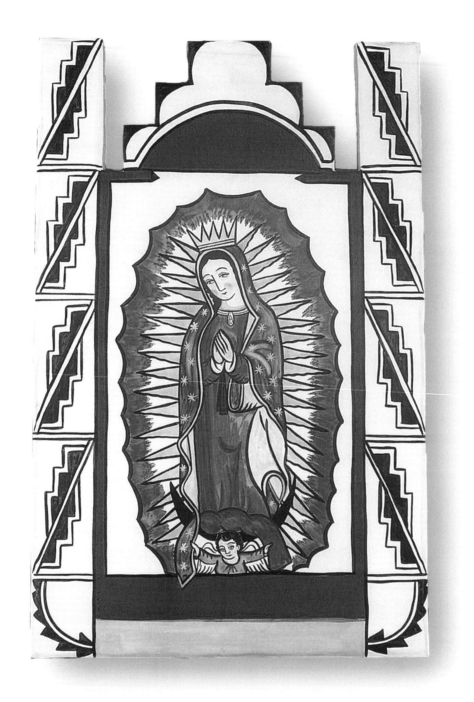

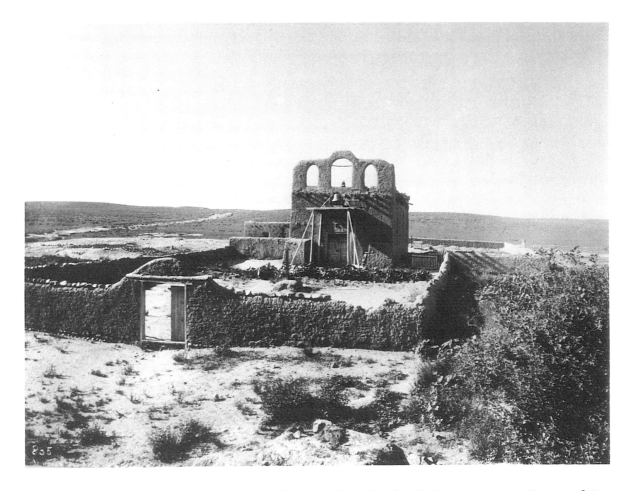

Nuestra Señora de Pojoaque Church, Pojoaque Pueblo, 1899. Photo by Adam C. Vroman, Courtesy Museum of New Mexico, neg. no. 13897.

san felipe pueblo
san felipe

San Felipe is an Eastern-Keresan-speaking pueblo located between Albuquerque and Santa Fe on the west bank of the Rio Grande. The pueblo, a three- or four-storied castle (Hammond and Rey 1953:345), was named for San Felipe Apóstol as early as 1598 (Domínguez 1956:161). The first mission was built by Fray Cristóbal de Quiñones on the east side of the river; however, this church burned in 1607. After the Pueblo Revolt, the pueblo was abandoned and the inhabitants moved to Horn Mesa on the southwest side of Cochití Canyon. In 1692, the people living there returned and built a new church and a new pueblo by 1706 (Domínguez 1956:161).

San Felipe Apóstol, or Saint Philip the Apostle, is the patron saint and his feast day is celebrated on May 1. Some have questioned whether the patron is actually San Felipe de Jesús; the record, however, shows that the pueblo is named for San Felipe Apóstol (Domínguez: 1956:161); don Bernardo Miera y Pacheco, the great New Mexican

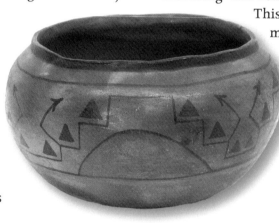

San Felipe Polychrome, ca. 1920, collection of Indian Pueblo Cultural Center, D89.20.1

santero who worked between 1756 and 1789, carved the major statue of San Felipe Apóstol. The retablo here depicts San Felipe Apóstol with the symbols of his evangelization.

San Felipe Pueblo is not noted for pottery production in the historic period; however, many Keresan-speaking pueblos, probably including San Felipe made Kiua Polychrome. This pottery dates from the mid-1700s to the end of the century. Characteristically the vessels are rag-polished with a white slip and painted with geometrical designs in carbon black and matte paint. Kiua pottery is also distinguished by a black rim top. The designs on this retablo are adapted from Kiua polychrome designs that date from 1780-1820.

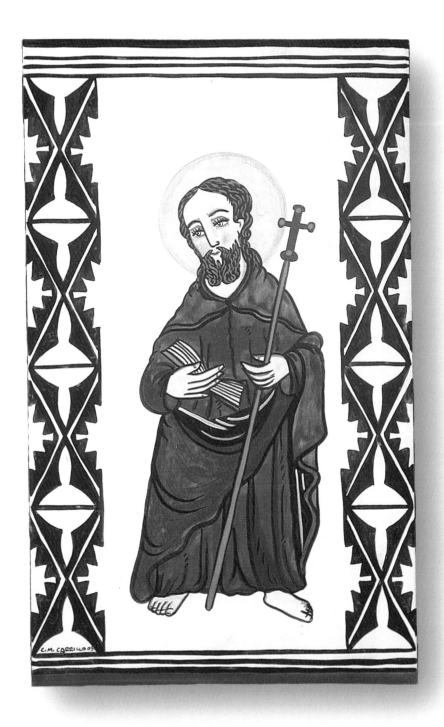

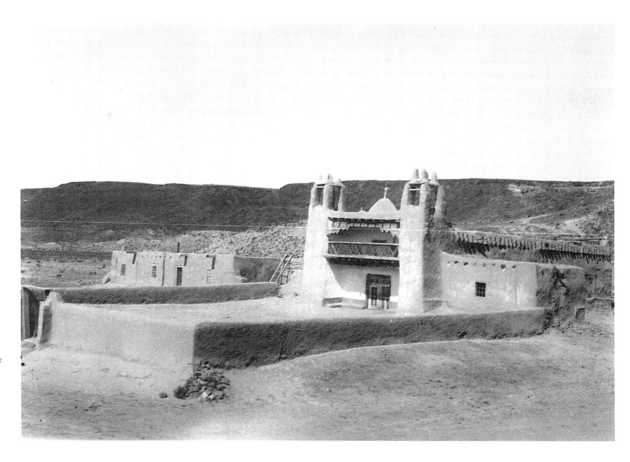

San Felipe Church, San Felipe Pueblo, DOD Collection, courtesy New Mexico State Records Center & Archives, #2806.

san ildefonso pueblo
san ildefonso

San Ildefonso (sometimes called *Pohwoge*) is a Tewa-speaking pueblo located 25 miles north of Santa Fe on the east bank of the Rio Grande. The present village dates to approximately 1300. The first mission was built at San Ildefonso in 1617 and destroyed in the Pueblo Revolt. This same structure was rebuilt in 1692 and destroyed again in the attempted revolt of 1696. It was not until 1717 that a new church was built (Whitman 1947:4). The colonial church fell into disrepair and was replaced by a new church in 1905. This church was replaced by a larger church on the same site in 1972.

San Ildefonso, or Saint Ildephonsus, lived from 607-667. Born in Agalia, Spain, he is known for his defense of the doctrine of the virginity of Mary in his famous work *De Virginitate Perpetua Sanctae Mariae*. He was named Archbishop of Toledo, Spain, in 657. His feast day is the 23rd of January. In this retablo, he is shown with a small statue of the Virgin Mary and dressed as an Archbishop of the 17th century.

The pottery elements used on this retablo come from two distinct vessels, one of which is in the collections of the Museum of New Mexico, a Powhoge Polychrome which dates from 1760-1790. The top finials of this retablo are based on feather designs tipped with cloud motifs. The center lunette design is adapted from a rim design of the same pot and the upright border designs are adapted from a San Ildefonso Polychrome vessel in a private collection dating from 1880-1910.

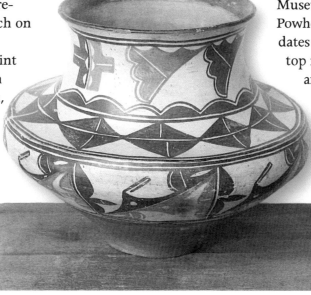

San Ildefonso Polychrome, ca. 1900, collection of Robert and Cynthia Gallegos.

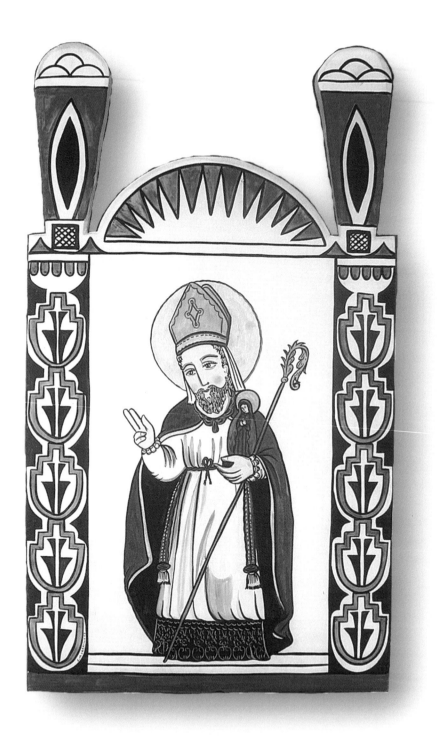

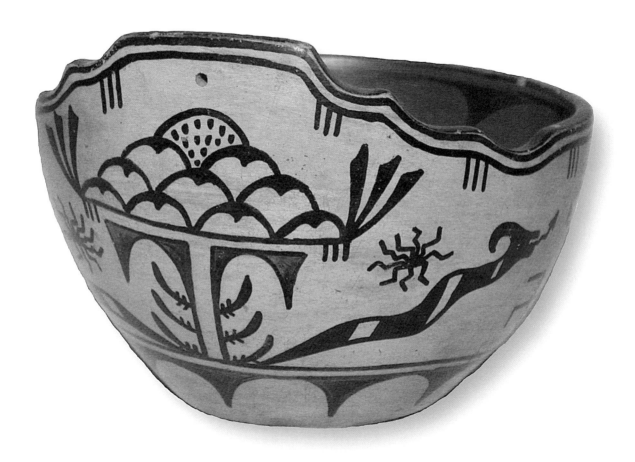

San Ildefonso Polychrome, ca. 1880. Private collection.

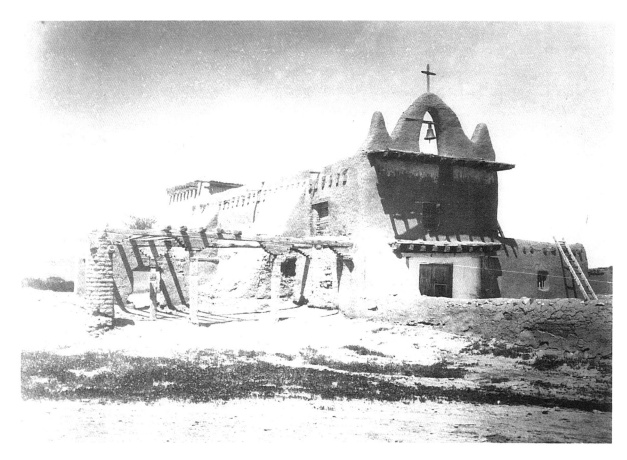

San Ildefonso Church, San Ildefonso Pueblo, DOD Collection, courtesy New Mexico State Records Center & Archives, #2803.

sandía pueblo
san antonio de padua de sandía

Sandía is a Southern-Tiwa-speaking pueblo located on the east bank of the Rio Grande between Albuquerque and Bernalillo. The pueblo has been occupied from at least 1300 (Stubbs 1950:31). This pueblo has been renamed at least three different times by the Spanish, each time bestowing a new patron saint.

Bandelier notes, it was named San Francisco in 1617 (Bandelier 1890-1892, 3:220). After the Pueblo Revolt, the pueblo was burned by Antonio de Otermín, governor of New Mexico. Some stories indicate that the Sabdia people fled to Hopi. The Pueblo of Sandía remained abandoned until 1748. By the 1760s there is some evidence that two groups settled back at the present pueblo, one Hopi and one Sandía. Most of the settlers, however, were a mixed group of pueblo refugees (Brandt 1979:345). The pueblo was originally dedicated to St. Francis. By the time of the Pueblo Revolt, Nuestra Señora de Dolores and San Antonio together were its patrons. Since about 1748, San Antonio has been the major patron saint.

San Antonio de Padua, or Saint Anthony of Padua, was a Franciscan who became known as a miracle worker. All over the world this saint is known as the patron saint of lost objects. He lived from 1195 to 1232 and is the second most popular male saint of colonial New Mexico (Awalt and Rhetts 1998:173). He is dressed in the blue robes of the Conceptionist Franciscans who missionized New Mexico. He holds the Christ Child on his left arm and a lily in his right hand. His feast day is June 13.

Sandía Pueblo is not noted for a pottery tradition, although pottery was made there. No historic pottery was available for illustration purposes. Puname Polychrome pottery is usually found from Zía Pueblo; however, the design on this retablo was derived from a Puname Polychrome from Sandía. Puname Polychrome dates from 1700-1760 and is distinguished by bowls and jars with distinctive sculptural shapes, such as an undercut underbody, mid-body bulge, and insloping upper body. The circular-eye element in the black border elements of this design may be a "rainbird" motif.

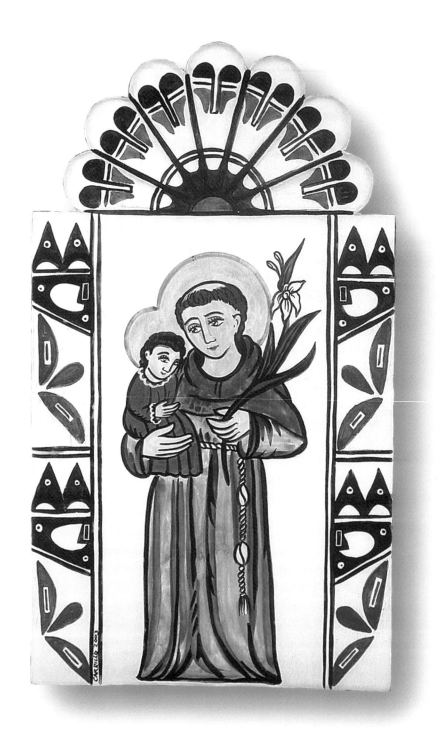

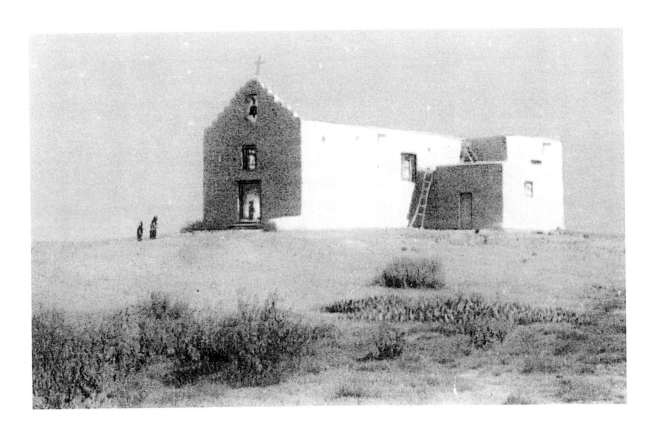

San Antonio de Padua de Sandía Church, Sandía Pueblo, F. Marple Collection, courtesy New Mexico State Records Center & Archives, #21143.

S anta Ana Pueblo is an Eastern-Keresan-speaking pueblo located northwest of the town of Bernalillo, N.M. The present pueblo has been occupied since the late 1500s and was named for Santa Ana in 1598. After the Pueblo Revolt, the present pueblo was resettled in 1692. A church was built in 1706 and then rebuilt in 1734 (Strong 1979:317-323).

Santa Ana, or Saint Anne (Ann), is the name of the mother of the Virgin Mary and the grandmother of Jesus. She is known from apocryphal accounts. Her feast day is July 26, the day following the feast day of Santiago, or Saint James, patron saint of horsemen. Saint Anne is patroness of women who ride horses. She is shown with the Virgin Mary.

The ceramic history of Santa Ana Pueblo was shared with Zía Pueblo until about 1750. The use of brick-red clay and white slip continued throughout the period. These pots tend to use a fine sand temper. Santa Ana potters developed a unique blocky-architectural style in their painted designs.

The pottery design on the border motif is derived from Santa Ana Polychrome, a pottery type that dates from 1800 to about 1920. This polychrome is noted for large red areas surrounding negative unpainted elements. The paint is mineral black and matte red on a coarse stone-stroked light tan slip. In the later part of the 1800s, the slip was changed to a chalky white.

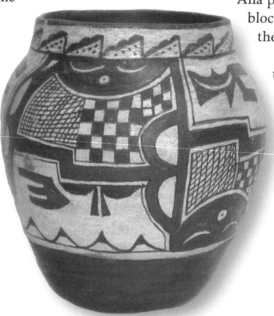

Santa Ana Polychrome, Dora Montoya- ca. 1965, collection of Bill and Barbara Douglas.

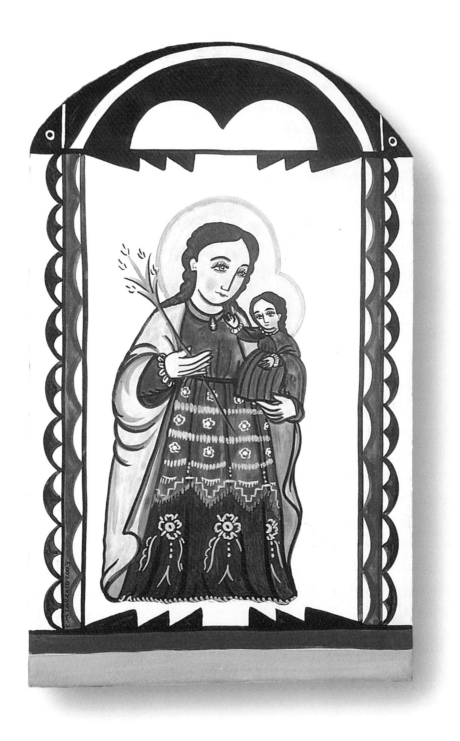

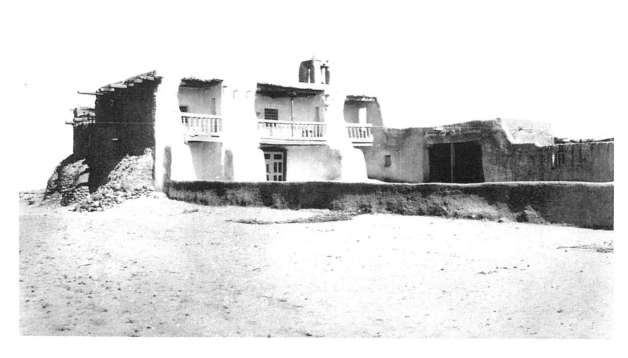

Santa Ana Church, Santa Ana Pueblo, ca. 1899, DOD Collection, courtesy New Mexico State Records Center & Archives, #2802.

santa clara pueblo
santa clara

Santa Clara is a Tewa-speaking pueblo located on the west bank of the Rio Grande, south of Española, N.M. The present pueblo has been occupied for at least 400 years. Numerous early Spanish expeditions likely encountered Santa Clara. Juan de Oñate named the village in 1598. A Franciscan mission and monastery was established at the pueblo sometime between 1622 and 1629 and also named for Santa Clara (Hodge 1910:456-457). This structure was destroyed during the Pueblo Revolt in 1680 and was rebuilt in 1706; after it collasped, a third church was begun in 1758.

Santa Clara, or Saint Clare, lived from 1193-1253. With the help of St. Francis of Assisi, she founded the Poor Clares. St. Clare was born in Assisi, Italy. Her feast day is August 12. She is shown in the garb of the Poor Clares and holding a monstrance (a metal container that holds the Holy Communion) and a crosier (a

Santa Clara Polished Blackware, ca. 1900, collection of Bill and Barbara Douglas.

pastoral staff).

Graceful, but plain polished black wares are typical at Santa Clara. Carving designs into the clay has been a decorative style tradition at Santa Clara, which is seldom found at other pueblos. The top of this retablo is shaped like the distinctive Santa Clara Black ware. This retablo design was influenced by the flaring rims of the Kapo Black wares made at Santa Clara Pueblo during the late 19th century. Santa Clara potters have commonly employed the bear paw design (seen at the top of the retablo), considered to be a trademark of this village, since the mid-1800s.

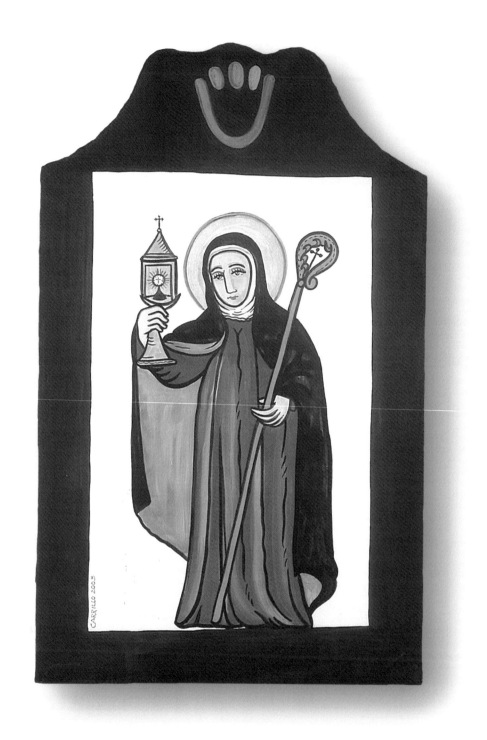

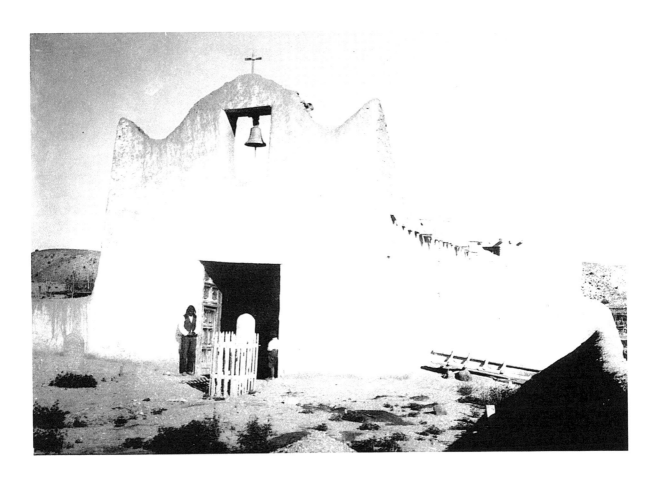

Santa Clara Church, Santa Clara Pueblo, DOD Collection, courtesy New Mexico State Records Center & Archives, #2800.

santo domingo pueblo
santo domingo

Santo Domingo is a Eastern-Keresan-speaking pueblo located on the east bank of the Rio Grande southwest of Santa Fe, N.M. Santo Domingo is one of the largest of the nineteen New Mexican pueblos. Santo Domingo was recorded as early as 1583 by Spanish explorers (Hammond and Rey 1953:1:337). The present village was built in the Colonial period and dates prior to 1776, when Domínguez wrote about the large pueblo (Domínguez 1956:130-138). In 1776, Domínguez described the existence of two churches. The newer church was located side by side with the original one. Disastrous floods impacted the churches in 1780, 1823, 1830, and 1885; in 1886 both churches were washed away. The current church, built in 1895, was renovated in 1972. Santo Domingo villagers are known throughout the Pueblo world for their elaborate and colorful feast days.

Santo Domingo, or Saint Dominic, lived from 1170-1221 and founded the Dominican Order in 1215. He is credited with the introduction of the Catholic devotion of the rosary. He is shown in the robes of his order, with a book, a white lily, and a rosary. His feast day is on August 8.

Santo Domingo potters have produced their serviceable bowls and ollas with the same basic materials since the 1700s. Changes have been few; the stone-polish and red band have been replaced with a rag-applied red underbody.

Santo Domingo Black-on-Cream, ca. 1900, collection of Bill and Barbara Douglas.

The top of this retablo is shaped like a tablita (a wooden panel worn as a headdress), which is worn by a woman dancer during the Corn Dance. The border motif is a copy of a classic Kiua Polychrome vessel found in a private collection. Kiua pottery is generally characterized by black on cream designs in horizontal bands of repeated geometric elements. This design dates from 1860-1940.

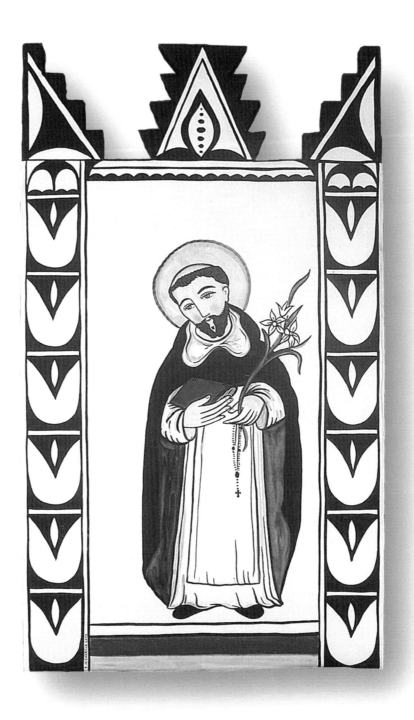

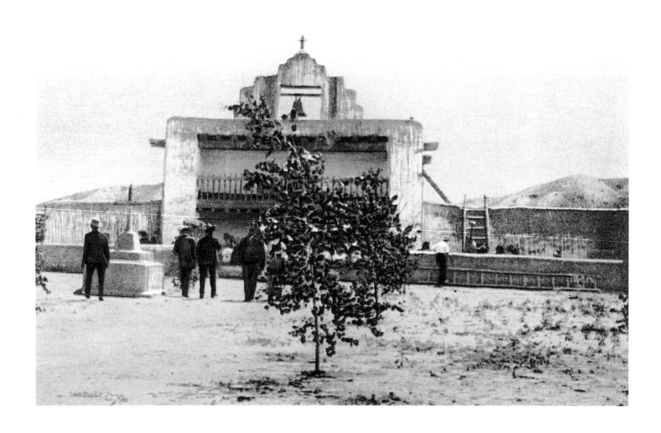

Santo Domingo Church, Santo Domingo Pueblo, F. Marple Collection, courtesy New Mexico State Records Center & Archives, #21141.

T aos is a Northern-Tiwa-speaking pueblo, located approximately 70 miles north of Santa Fe. N.M. Taos is the largest multi-storied pueblo of New Mexico. The Pueblo of Taos was recorded as early as 1541 by Castañeda (Hammond and Rey 1940:244). Fray Atanasio Domínguez details Taos in 1776 (Dominguez 1956:758-59). The church of San Gerómino, built in 1706, was destroyed by the U.S. Army after the 1847 revolt against American occupation; the ruins of this church still remain. A new church was built around 1850, located on the north plaza.

San Gerómino, or Saint Jerome, who lived from 342 to 420, is known for his translations of the Bible from Hebrew and Greek into Latin. In New Mexican Colonial art, he is depicted as a scantily clothed bearded hermit. He wears a red cardinal's cape, and holds a stone to his chest as a symbol of his penance. A trumpet, representing the voice of God, typically appears in an upper corner of the image. He is often shown with a lion at his feet. His feast day is September 30. Jerome is the ninth most important male saint in New Mexico (Awalt and Rhetts 1998:173).

Taos Micaceous, ca. 1930, collection of Charlie and Debbie Carrillo.

In this rendition, the top rosette is painted with baroque elements similar to those used by the Arroyo Hondo Santero, a historic *santero* from the Taos area.

Taos is not known for painted pottery; however, it is quite well known for its micaceous wares, especially its bean pots. Micaceous clay is abundant in the Taos area. The clay needs no additional temper and firing is simple, since smoke clouds are of the style. The border design of this retablo is painted with micaceous clay.

63

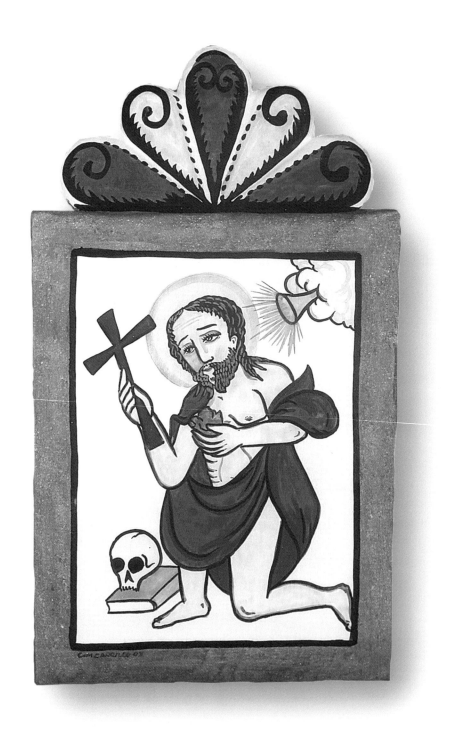

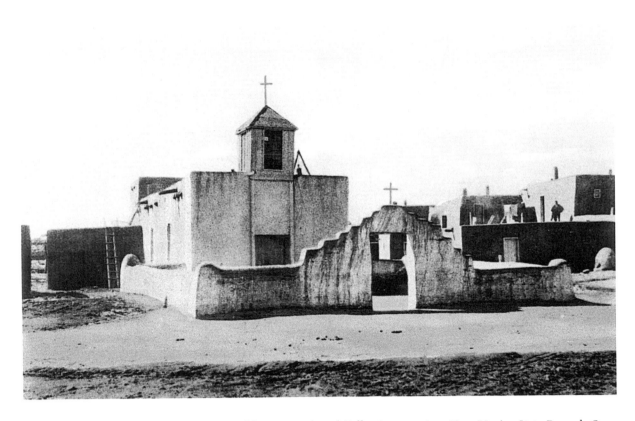

San Gerónimo de los Taos Church, Taos Pueblo, D. Woodward Collection, courtesy New Mexico State Records Center & Archives, #22226.

tesuque pueblo
san diego de alcalá de tesuque

Tesuque is a Tewa-speaking pueblo located north of Santa Fe on the Tesuque River. Fray Cristóbal de Salazar missionized Tesuque in 1598, when it was known as San Lorenzo de Tesuque (Coan 1925, 1:66). Sometime after 1694, the pueblo was renamed San Diego de Alcalá de Tesuque. The church was built in 1915 and incorporated parts of the earlier historic church. A new church was built in 2002 after fire destroyed the church that was built in 1915.

San Diego de Alcalá, or Saint Didacus, lived from 1400 to 1453 and was introduced into New Mexico by the Franciscans shortly after he was canonized in 1588. He became popular when King Philip of Spain promoted his devotion because he believed that Diego cured his son Don Carlos. San Diego is shown dressed as a Franciscan, holding a basket of flowers and a small cross. His feast day is November 12.

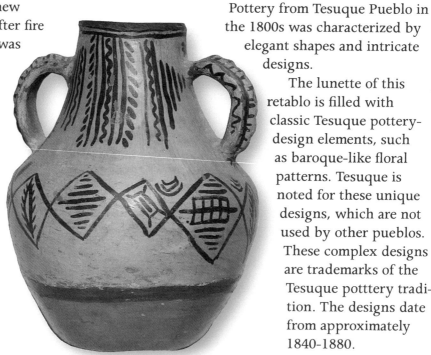

Tesuque Black-on-Cream, ca. 1900, collection of Paul Rhetts and Barbe Awalt.

Pottery from Tesuque Pueblo in the 1800s was characterized by elegant shapes and intricate designs.

The lunette of this retablo is filled with classic Tesuque pottery-design elements, such as baroque-like floral patterns. Tesuque is noted for these unique designs, which are not used by other pueblos. These complex designs are trademarks of the Tesuque potttery tradition. The designs date from approximately 1840-1880.

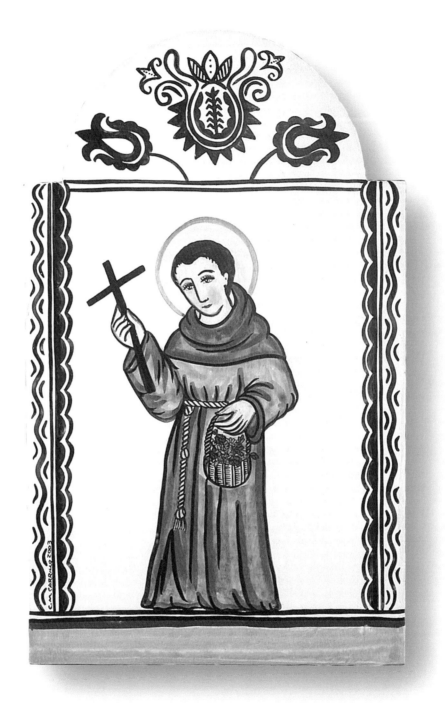

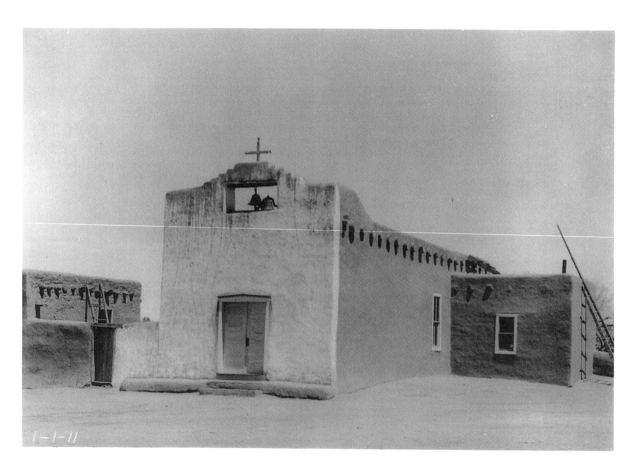

San Diego de Acalá de Tesuque Church, Tesuque Pueblo. Courtesy Museum of New Mexico, neg. no. 4753.

zía pueblo
nuestra señora de la asunción de zía

The Pueblo of Zía is a Keresan-speaking village located on the Jémez River some 30 miles northwest of Albuquerque. Members of the Coronado expedition likely encountered the people of Zía in 1540. In 1583, Antonio de Espejo referred to the Zía people as *Punames* (Pérez de Luxán 1929:83-85). The first mission to be built in Zía was constructed between 1610-1613. This church was destroyed in the Pueblo Revolt of 1680. Diego de Vargas ordered the re-establishment of the Zía mission in 1692, and the church was rebuilt. The present Pueblo mission is one of the oldest missions to occupy a pre-Revolt site and has been refurbished many times. Domínguez mistakenly called the Pueblo *Nuestra Señora de la Purísima Concepción (Domínguez 1956:171-172).*

The title of the Virgin Mary known as Nuestra Señora de Asunción, Our Lady of the Assumption, refers to the doctrine of the Roman Catholic Church that maintains that the Virgin Mary was assumed body and soul into heaven at the time of her dormition. The Pueblo celebrates her feast day on August 15. The prototype for this retablo is based upon the 18th century altar screen painting of the Virgin as is known from the present mission. This altar screen is attributed to the great anonymous New Mexican artist known as the Laguna Santero.

The brick-red clay of Zía pottery is tempered with crushed basaltic rock, creating a hard-fired vessel. The design system in these pots has remained relatively consistent for over three centuries, utilizing arches, stylized birds, and water symbols.

The pottery design chosen for this retablo is known as Trios Polychrome and dates from 1800-1850. The pottery type exhibits a coarse stone-stroked paste on which is floated or scrimmed over a light whitish-tan slip. The painted designs consist of bold orange or red matte and mineral black paints.

Zía Polychrome, ca. 1900, collection of Robert and Cynthia Gallegos.

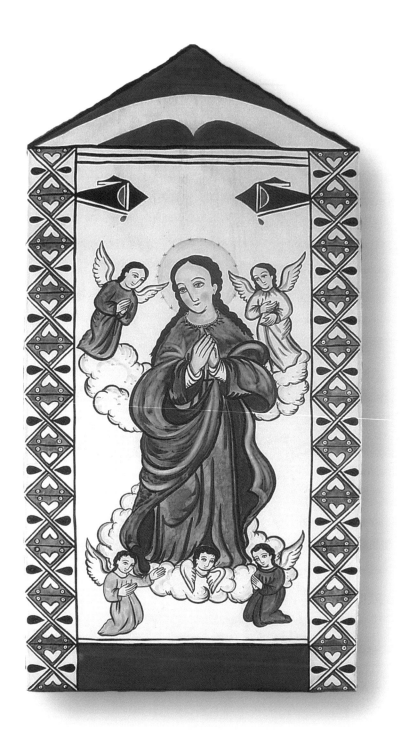

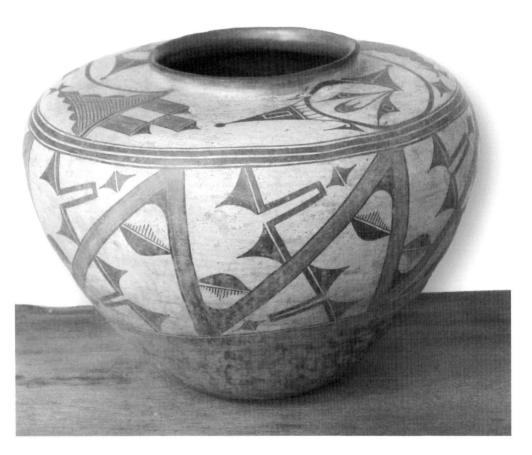

Zía Polychrome, ca. 1880, collection of Robert and Cynthia Gallegos.

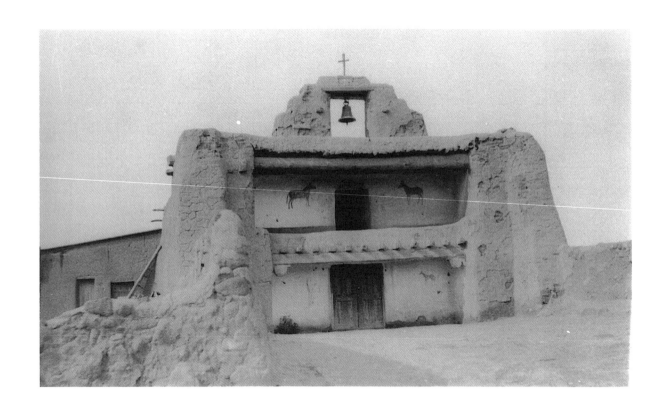

Nuestra Señora de la Asunción de Zía Church, Zía Pueblo. Courtesy Museum of New Mexico, neg. no. 4287.

zuni pueblo
nuestra señora de guadalupe de zuni

Fray Marcos de Niza, a Franciscan priest guided by Estéban who was a black slave, was the first European to see the Zuni villages in 1539. His report of the Zuni villages and other western pueblos was the catalyst that generated enough interest that Francisco Vásquez de Coronado came to New Mexico in 1540. He eventually "captured" Hawikuh in July 1540 (Hammond and Rey 1940).

By 1629, a mission was built a Hawikuh, and, by 1632 a mission was also completed at the present site of the Zuni Pueblo known as Halona. The pueblo word for Zuni is *Ashiwi*. The Mission at Hawikuh was destroyed in the Pueblo Revolt in 1680. The Zuni peoples saved many of the ritual objects from destruction in the 1680 Revolt and re-established their mission at Halona. The mission was known as Nuestra Señora de Guadalupe de Zuni, or Our Lady of Guadalupe of Zuni. Don Bernardo Miera y Pacheco, an artist and engineer who emigrated from Northern Spain in the late 1750s, was responsible for the

Zuni Polychrome, ca. 1870, collection of Indian Pueblo Cultural Center, D89.21.1.

great altar that once stood in the mission. The mission remained in ruins until 1966-67 when Pueblo leaders rebuilt it. Today, the inner walls contain the master works of the Zuni artist Alex Seotewa and his sons.

The locally gathered clay is frequently tempered with crushed potsherds. As opposed to the white clay from Ácoma, Zuni's clay is predominantly pink. Zuni black paint is apt to be brown, and, since 1800, Zuni jars have black or dark brown underbodies rather than red.

In this retablo, the Virgin of Guadalupe is dressed in a Zuni *manta* (a wrap or dress). This rendition was based on a historic photograph of a Zuni maiden, which was printed backwards. It should

be noted that the *manta* actually is never worn over the left shoulder. The bottom of the *manta* is trimmed with traditional indigo embroidery on the lower portion. She also wears a Zuni maiden haircut of the 1870s. The Virgin wears traditional foot gear — calf-length whitened deer-skin wrappings over moccasins. Her body halo consists of traditional Zuni feather motifs. Her feast day is December 12. The Virgin of Guadalupe is the second most frequent image of the Virgin (Awalt and Rhetts 1998:173).

The pottery design on the border consists of three pottery types: Ashiwi Poly- chrome, dating from 1700-1760; Kiapkwa Poly- chrome, dating from 1780-1820;

and Zuni Polychrome, dating from 1850-1890. Kiapkwa Polychrome from Zuni resembles Ashiwi Polychrome, except for the use of fewer feather motifs and distinctive neck and lip shapes. Zuni Polychrome is similar to both in paste and slip; however, the use of "rain-bird" design elements, heart-line deer motifs, and cross hatching distinguish this pottery type.

The bottom four-pointed star motifs are derived from Ashiwi Polychrome, which is noted for its predominance of feather designs and matte black and red mineral paint on a stone-polished creamy white slip (Harlow 1973:88).

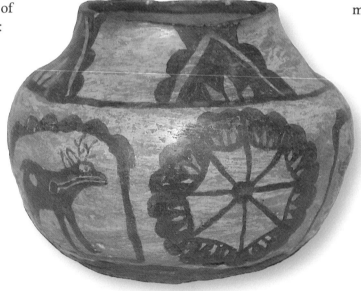

Zuni Polychrome, ca. 1890, collection of Paul Rhetts and Barbe Awalt.

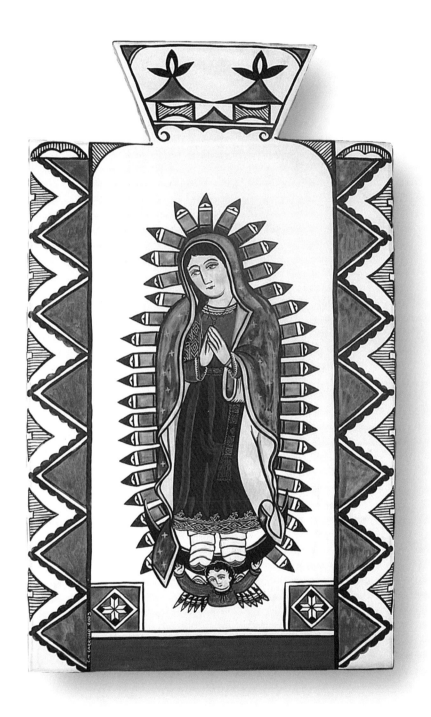

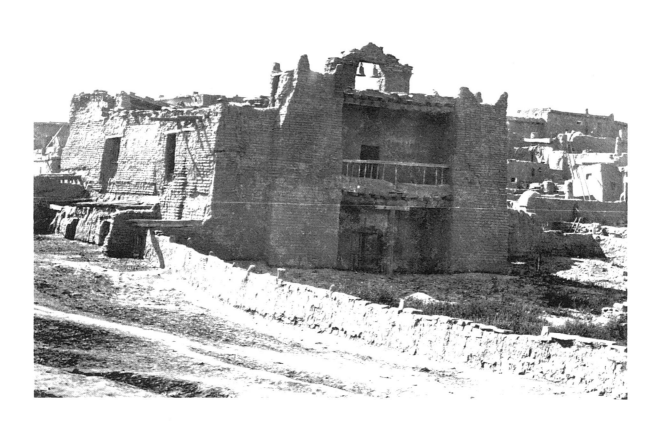

Nuestra Señora de Guadalupe de Zuni Church, Zuni Pueblo, ca. 1873. DOD Collection, courtesy New Mexico State Records Center & Archives, #2799.

From the time of Spanish colonization in 1598 until the mid-18th century, many pueblos in New Mexico were abandoned and consolidated. During the Pueblo Revolt of 1680, some Pueblo peoples left the upper Rio Grande to establish new pueblos in the El Paso area. Most of the pueblos in central New Mexico as well as many pueblos east of the central mountain chain were abandoned in the 1670s due to drought, famine, and Apache raids. This section represents four of the pueblos abandoned during this period. These sites were selected because they are accessible to the general public.

abó pueblo
san gregorio de abó

In 1598, Juan de Oñate visited the Jumanos Pueblo of Tompiro-speaking peoples, which he called Abó. Fray Francisco de Acevedo founded the Mission of San Gregorio at the pueblo in 1629. The mission was abandoned prior to the Pueblo Revolt of 1680. In 1981, the archaeological site became part of the Salinas Pueblo Missions National Monument (Julyan 1996:2).

San Gregorio, or Saint Gregory the Great, is considered a father of the Western Church. His feast day is March 12. He lived from about 540 to 604. He joined the Benedictine Order and, following a mission to Byzantium, became secretary to Pope Pelagius II. He was the first monk to become the Pope. He is known for the development of the liturgy for the mass and for reformed ecclesiastical discipline.

Gregorio is shown in Colonial art with a tiara (papal crown) and a model of the church. He also holds a crosier with three crossbars, which is an attribute of the Pope.

The design on this retablo is derived from a style of pottery referred to as Glazeware. This glazeware style is called Kotyiti Glaze Polychrome. It was named for a fortified pueblo located on a Mesa top near Cochití. The pottery style is part of late glazeware groupings that were made until the time of the Pueblo Revolt in 1680. Kotyiti Glaze Polychrome is distinguished by a "runny" glaze that resulted from a glaze-paint vitrification. Jars and bowls are distinguished by flaring rims, angular bends, concave bases and lipped rims. The glaze is a shinny dark-brown color.

Reconstructed Kotyiti Glazeware jar. Courtesy of Salinas Pueblo Missions National Monument Museum Collection.

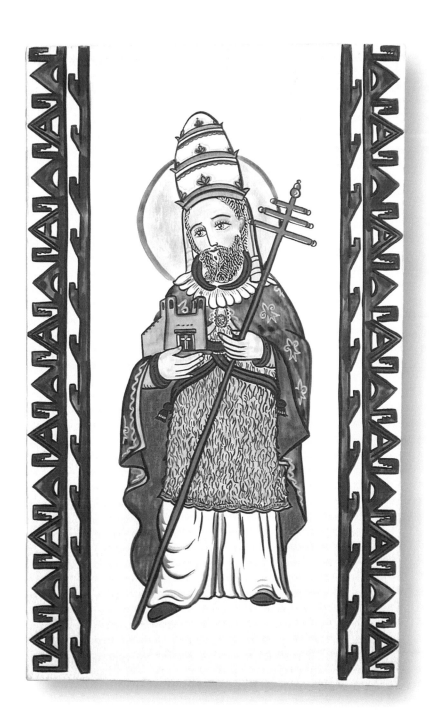

gran Quivira pueblo
san isidro labrador de gran Quivira

This Tompiro Pueblo was first visited by Juan de Oñate in 1598 and referred to as *Pueblo de los Jumanos* (Humanos), the "town of the striped ones." Apparently the inhabitants of this pueblo painted a stripe across their noses. The first small church built at the pueblo was called San Isidro. Fray Diego de Santander built the second larger church there and named it San Buenaventura. By the 1670s the pueblo and mission were abandoned because of an extended drought and attacks by nomadic Apache groups. The ruins have been preserved first as Gran Quivira National Monument, and now as part of Salinas Pueblo Missions National Monument (Julyan 1996:152).

San Isidro Labrador, or Saint Isidore the Plowman, was born in Madrid, Spain (d. 1170). Isidro worked the land of Juan de Vargas (note: New Mexico was colonized by don Diego de Vargas of the same lineage). His feast day is May 15. It is said that angels sometimes were sent by God to help Isidro with his work. His wife, Maria de la Cabeza, a very devout woman who administered to the poor, is also a saint.

In this retablo, Isidro is depicted in a traditional outfit of 18th century New Mexico. He holds a hocking iron, which is known in New Mexico as a *desjarratadera*.

The border design on this retablo was adapted from four different Tabirá Polychrome pots; one is pictured on page 86 and another is pictured below. Tabirá Polychrome was only made in the Jumanos Pueblos from approximately 1650 to 1672. This ware is distinguished by fugitive red and yellow paints that fill the black and white designs. This type of pottery is the rarest pottery type found in pre-Revolt New Mexico.

Tabirá Polychrome sherd. Courtesy of Salinas Pueblo Missions National Monument Museum Collection.

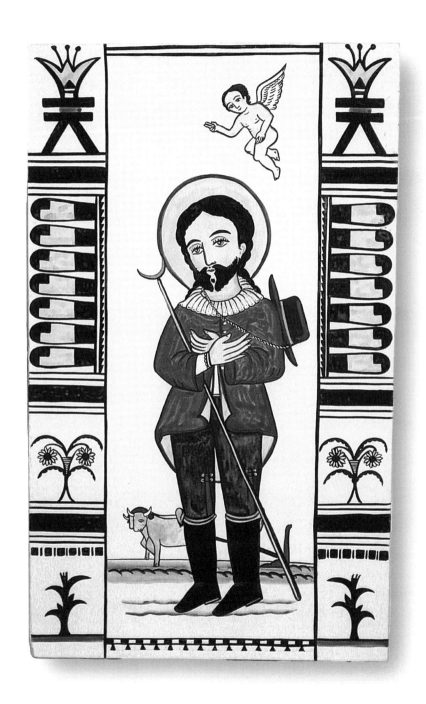

pecos pueblo
nuestra señora de los angeles de porciúncula de pecos

The Towa-speaking Pueblo of Pecos was first visited by Coronado in 1540. Scholars believe that at that time Pecos Pueblo was one of the largest settlements in North America, north of Mexico. The Keres name for the pueblo was Pecos and was adopted by Oñate in 1598. He assigned missionaries to the pueblo at this time (Hammond and Rey 1953). The Spanish mission has been referred to as Nuestra Señora de los Angeles de Porciúncula de Pecos since 1692-93. It was abandoned in 1838, when the last remaining survivors moved into the Towa-speaking Pueblo of Jémez. The site is now known as Pecos National Historical Park (Julyan 1996:260).

Nuestra Señora de Los Angeles de Porciúncula, or Our Lady of the Angels of Poziuncula, is a title of the Virgin Mary; her feast day is August 2. This title is named for the Porzincula Chapel in the Basilica of Santa Maria degli Angeli near Assisi, Italy, which was the site of the first monastery founded by St. Francis, who died at Poziuncula in 1226. The Colonial

Kotyiti Glazeware sherd. Courtesy of Salinas Pueblo Missions National Monument Museum Collection.

New Mexican painting brought from New Spain of Our Lady of Porciúncula depicts her in a blue cloak, ascending into heaven, and surrounded by angels; this painting is now in the Pecos village church.

The border design for this retablo is derived from Pecos Glazeware pottery (1375 to 1700), which has designs painted in a dark-brown glaze. The glaze is made from a mineral called *galena* (lead ore). Pecos Pueblo was an important trade center for late glazewares. This retablo uses two distinctive glaze designs from Pecos. The interlocking motif is known as a "double key" design; the human figures, which were called "Capitans," are now referred to as "feathered serpents."

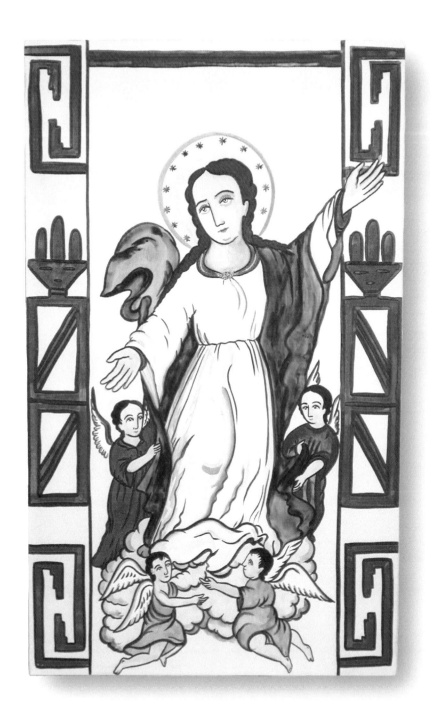

This Tiwa-speaking pueblo was the site of a mission established in 1629 and named Nuestra Señora de Querac, ou La Concepción. A long drought from the 1660s to the 1670s caused the inhabitants of this pueblo to abandon it by 1671. The archaeological site was established as a national monument in 1935, and, in 1981, it became part of the Salinas National Monument (Julyan 1996:280).

Nuestra Señora de la Purísima Concepción, or Our Lady of the Immaculate Conception, is a title of the Virgin Mary; her feast day is celebrated on December 8. The Roman Catholic Church maintains the doctrine that Mary was conceived without original sin. The Franciscans who missionized New Mexico wore the color blue in honor of Mary. They were called Conceptionist Franciscans. This doctrine, although popular in 17th century New Mexico, was solemnly proclaimed by Pope Pius IX in 1854. Mary stands on a crescent moon supported by angels. She is often crowned, and twelve stars surround her head, a reference to Revelations 12:1. She wears a blue mantle, the celestial color of heaven.

The design for this retablo is derived from a Tabirá Polychrome canteen, which is pictured below. The use of a soft yellow is unique in Pueblo pottery history. This pottery type was made only from 1650 to 1672 when the entire Salinas district was abandoned. It is likely that the use of yellow may have been influenced by the imported majolica wares that the Franciscans brought from New Spain (Mexico).

Reconstructed Tabirá Polychrome canteen. Courtesy of Salinas Pueblo Missions National Monument Museum Collection.

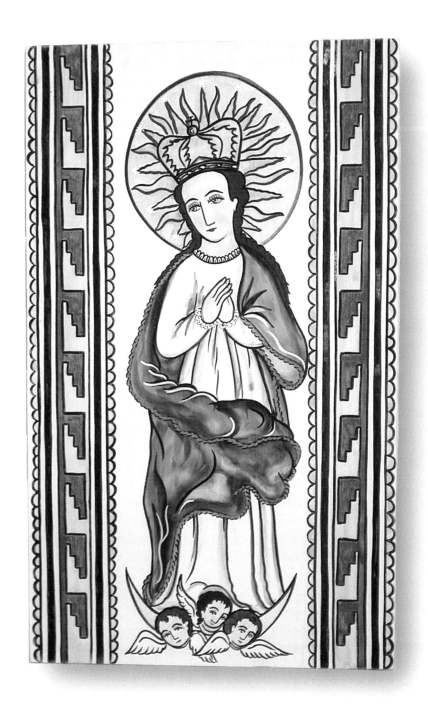

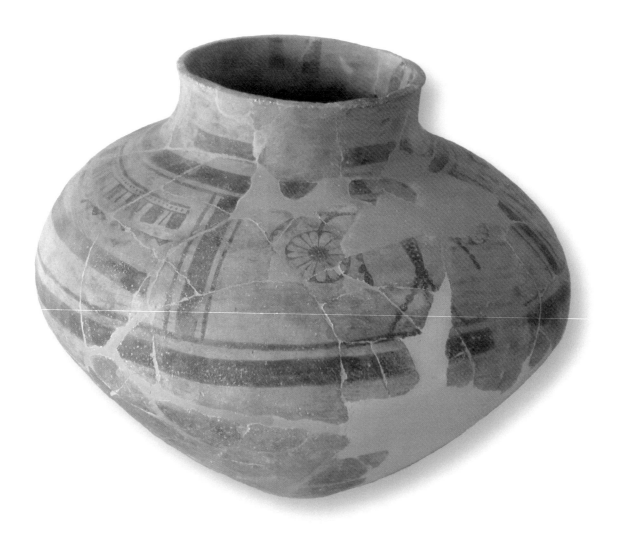

Reconstructed Tabirá Polychrome jar. Courtesy of Salinas Pueblo Missions National Monument Museum Collection.

glossary

alcalde – an official having judicial powers.

alguacil – sheriff.

ashiwi – a type of polychrome pottery made at zuni pueblo from 1700 to 1760. it uses a mineral matte paint.

boss – small rounded projections or bumps on the surface of a pot.

capitan – human forms found on late glazewares.

carbon paint – black firing pigment that is the boiled down residue of organic matter.

finial – ornamnetal addition to the top of a retablo or altarscreen.

glazeware – a type of pottery on which designs were painted with a glaze.

hand-azed – wood that has been planed by hand, using an adze.

incised – marks or deorations cut into the surface of a pot.

indigo – a blue dye obtained from various plants, esp. of the genus indigofera.

jumanos – a group of pre-revolt pueblos located in the salinas district of central new mexico.

kapo – a type of smudged, polished black or gray pottery from tewa pueblos from the 18th century.

keres – a group of pueblos with a common language, including acoma, cochití, laguna, sandia, san felipe santa ana, santo domingo, zía, and zuni pueblos.

key design – a decorative design on pottery that resembles the notches on a key.

kiapkwa – a type of zuni pottery from 1780 to 1820.

kiua polychrome – multi colored pottery from keres-speaking pueblos (especially santo domingo, 1760 to present, and cohcití, 1760–1850).

kotyiti polychrome – a type of 17th century glazeware.

lunette – a cresent or semicircular shape at the top of a retablo or painted panel.

majolica – a tin glazed decorated pottery of european or mexican origin.

micaceous – clay containing mica.

pigment – a coloring substance which when suspended in water becomes paint; pigments can come from plant material or earth/clays.

piñon sap varnish – a varnish made from the sap of the piñon pine tree, applied to the surface of retablos.

polished – the application of a rag or stone to the surface of a pot to smooth and create a luster.

polychrome – use of several colors in the decoration of a pot.

potsuwi'i – a prehistoric tewa pottery type with incised designs.

powhoge – a type of polychrome tewa pottery, which is matte painted and made after 1760. it is the indian name for san ildefonso pueblo.

puname – a type of matte painted keres pottery from 1700 to 1760, especially from zía pueblo.

red ware - pottery having one or both surfaces slipped with red firing clay.

retablo – a devotional panel with a painting of a saint or holy image.

rope fillet – a narrow band or ribbon around the top of a pot used a s a decoration.

santo - a devotional image of a saint or holy image in either two dimensions (retablos or altarscreens) or three dimensions (bultos or carved images).

santero - a maker of santos or holy images.

slip (tan, white, red) – a clay solution of creamy consistency for coating or decorating a pot; it can be incised.

stone stroked – a method of polishing a pot with a stone.

tabirá polychrome – a pottery type from the Jumanos district made from 1650 to 1672.

Tewa – a group of pueblos with a common language, including Nambé, Pojoaque, San Ildefonso, San Juan, and Santa Clara pueblos.

Tiwa – a group of pueblos with a common language, including Isleta (southern Tiwa), Picurís, and Taos pueblos.

Tompiro - a language group, especially found in the Jumanos district. this language group is now extinct.

Towa – a group of pueblos with a common language, including Jémez and Pecos pueblos.

Trios Polychrome – a type of Keres pottery that is matte painted polychrome, especially from Zía pueblo made from 1800 to 1850.

utilitarian ware – pottery whose primary function is the storage or cooking of food.

bibliography

Awalt, Barbe, and Paul Rhetts
1998 *Our Saints Among Us: 400 Years of New Mexican Devotional Art*. Albuquerque: LPD Press.

Bandelier, Adolf F.
1890-1892 *Final Report of Investigations Among the Indians of the Southwestern United States, Carried mainly in the Years from 1880 to 1885*. Cambridge: Archaeological Institute of America.

Bancroft, Hubert H.
1889 *History of Arizona and New Mexico, 1530-1888*. San Francisco: The History Company (Reprinted Albuquerque: Horn and Wallace, 1962).

Benavides, Alonso de
1945 *Fray Alonso de Benavides Revised Memorial of 1634*. Fredrick W. Hodge, George P. Hammond, and Agapito Rey, eds. Albuquerque: University of New Mexico Press.

Biblioteca Naciónal Archivo
v.d. *Legajo X*, Documents 79,80.

Bloom, Lansing B.
1946 "The West Jemez Culture Area," *New Mexico Historical Review* 21(2) 120-126.

Bolton, Herbert E. (ed.)
1916 *Spanish Explorations in the Southwest, 1542-1706*. New York: Charles Scribner's Son.

Boyd, E.
1974 *Popular Arts of Spanish New Mexico*. Museum of New Mexico Press. Santa Fe.

Brandt, Elizabeth A.
1979 "Sandia Pueblo," pp 343-350, *Handbook of North American Indians (Southwest, Vol. 9)*. Alfonso Ortiz, ed. Washington: Smithsonian.

Castaño de Sosa Gaspar
1965 *A Colony on Move; Gaspar Castaño de Sosa's Journal, 1590-1591*. Albert H. Schroeder and Dan S. Matson eds. and trans. Santa Fe: The School of American Research.

Coan, Charles F.
1925 *A History of New Mexico*. Chicago and New York.

Domínguez, Francisco A.
1956 *The Missions of New Mexico 1776: A Description by Fray Francisco Atanasio Domínguez, with Other Contemporary Documents*. Elanor B. Adams and Fray Angelico Chavez, trans. Albuquerque: University of New Mexico Press.

Ellis, Florence Hawley.
1979 "Isleta Pueblo," pp 351-365 *Handbook of North American Indians (Southwest, Vol. 9)*. Alfonso Ortiz, ed. Washington: Smithsonian.

Hacket, Charles W. (ed.)
1923-1937 *Historical Documents Relating to New Mexico, Nueva Vizcaya and Approaches Thereto, to 1773*. Adolph F. A. Bandelier and Fanny R. Bandelier. Washington: Carnegie Institute.

Hammond, George P., and Agapito Rey. eds. and trans.
1940 *Narratives of the Coronado Expedition, 1540-1542*. Albuquerque: University of New Mexico Press.
_____eds.
1953 *Don Juan de Oñate Colonizer of New Mexico, 1598-1628*. Albuquerque: University of New Mexico Press.

Harlow, Frances H.
1973 *Matte-Paint Pottery of the Tewa, Keres, and Zuni Pueblos*. Santa Fe: Museum of New Mexico Press.

Harrington, John P.
1916 "The Ethnogeography of the Tewa Indians," pp 29-636,*29th Annual Report of the Bureau of American Ethnology for the Years 1907-1908*. Washington.

Hodge, Fredrick W.
1910 "Santa Clara," pp 456-457, *Handbook of American Indians of North of Mexico (Vol. 2)*. Fredrick W. Hodge, ed.Washington: Smithsonian.

Jenkins, Myra E.
1966 "Taos Pueblo and its Neighbors, 1540-1847," *New Mexico Historical Review* 47(2); 113-134.

Juylan, Robert
1996 *The Place Names of New Mexico*. Albuquerque: University of New Mexico Press.

Lambert, Marjorie F.
1979 "Pojoaque Pueblo," pp 324-329, *Handbook of North American Indians (Southwest, Vol. 9)*. Alfonso Ortiz, ed. Washington: Smithsonian.

Ruppé, Reynold J. Jr.,
1953 *The Acoma Culture Province: An Archaeological Concept* (unpublished dissertation). Cambridge: Harvard University.

Pérez de Luxán, Diego
1929 *Expedition into New Mexico Made by Antonio de Espejo, 1582-1583 As Revealed in the Journal of Diego Pérez de Luxán, member of the party*. George Hammond and Agapito Rey, eds. Los Angeles: The Quivera Society.

Sando, Joe S.
1979 "Jémez Pueblo," pp 418-429, *Handbook of North American Indians (Southwest, Vol. 9)*. Alfonso Ortiz, ed. Washington: Smithsonian.

Scholes, France V.
1938 "Notes of the Jémez Missions in the 17th Century." *El Palacio* 44(1-2):61-102.

Scholes, Frances V.
1929 "Documents for the History of New Mexican Missions in the Seventeenth Century." *New Mexico Historical Review* IV:45-48.

Scholes, Frances V. and Lansing B. Bloom
1944/45 "Friar Personnel and Mission Chronology, 1598-1629." *New Mexico Historical Review* XIX:314-336; XX:58-82.

Spiers, Randall H.
1979 "Nambé Pueblo," pp 317-323, *Handbook of North American Indians (Southwest, Vol. 9)*. Alfonso Ortiz, ed. Washington: Smithsonian.

Steele, S.J., Thomas J.
1994 *Santos and Saints*. Santa Fe: Ancient City Press.

Strong, Pauline Turner.
1979 "Santa Ana Pueblo," pp 398-406, *Handbook of North American Indian (Southwest, Vol. 9)*. Alfonso Ortiz, ed. Washington: Smithsonian.

Stubbs, Stanley A.
1950 *Bird's eye View of the Pueblos*. Norman: University of Oklahoma Press.

Thomas, Alfred B., and trans
1935 *After Coronado: Spanish Exploration Northeast of New Mexico 1696-1727; Documents from the Archives of Spain, Mexico and New Mexico*. Norman: University of Oklahoma Press.

Whitman, William
1947 *The Pueblo Indians of San Ildefonso: A Changing Culture*. New York: Columbia University.

index

the author

Dr. Charles M. Carrillo is a scholar, teacher, and lecturer, as well as an artist. He has been a participant at Spanish Market in Santa Fe for almost thirty years and has won numerous awards. His work is exhibited in many major museums including The Heard Museum, Denver Art Museum, Regis University, Albuquerque Museum, Museum of Spanish Colonial Art, and the Smithsonian. Carrillo received the 2006 National Heritage Fellowship fromn the National Endowment for the Arts. He is the author of *Hispanic New Mexican Pottery* (1996), *A Tapestry of Kinship* (co-authored with José Antonio Esquibel, 2004), *A Century of Retablos* (co-authored with Thomas J. Steele, S.J., 2007), and *The Novena to the Santo Niño de Atocha* (co-authored with Thomas J. Steele, S.J. and Felipe Mirabal, 2007); he was a contributor to *Our Saints Among Us: 400 Years of New Mexican Devotional Art* (by Barbe Awalt and Paul Rhetts, 1998) and to *Nicholas Herrera: Visions of My Heart* (by Barbe Awalt and Paul Rhetts, 2003). He has also written many articles on New Mexico art and culture. Carrillo earned his doctorate in anthropology from the University of New Mexico and is currently an Adjunct Professor in the University of New Mexico's Religious Studies Program. A book on Carrillo and his art, *Charlie Carrillo: Tradition & Soul*, was published by LPD Press in 1994. The first Santos of the Pueblos exhibit at the Indian Pueblo Cultural Center in 2003 was so popular that an expanded version of the show was installed in its new gallery in 2004. Carrillo lives in Santa Fe with his wife Debbie, who is an award-winning potter, and their two children, Estrellita and Roán, who have also won awards for their santos.

CPSIA information can be obtained
at www.ICGtesting.com
Printed in the USA
LVIW012023191012

303578LV00002B